ALIENS AMONG US

Extraordinary Portraits
of Ordinary Bugs

DANIEL KARIKO

WITH DESCRIPTIONS BY TIM CHRISTENSEN

AND ILLUSTRATIONS BY ISAAC TALLEY

Liveright Publishing Corporation
A Division of W. W. Norton & Company
Independent Publishers Since 1923
New York • London

For information about permission to reproduce selections from this book, write to
Permissions, Liveright Publishing Corporation, a division of
W. W. Norton & Company, Inc., 500 Fifth Avenue, New York, NY 10110

For information about special discounts for bulk purchases, please contact
W. W. Norton Special Sales at specialsales@wwnorton.com or 800-233-4830

Manufacturing by RR Donnelley China
Book design by Beth Steidle
Production manager: Beth Steidle

ISBN 978-1-63149-426-0

Liveright Publishing Corporation, 500 Fifth Avenue, New York, N.Y. 10110
www.wwnorton.com

W. W. Norton & Company Ltd., 15 Carlisle Street, London W1D 3BS

1 2 3 4 5 6 7 8 9 0

I DEDICATE THIS BOOK TO THE MEMORY OF MY GRANDFATHER,
MILORAD PERIN, A MECHANIC, DENTIST, OCCASIONAL FORTUNE SEEKER,
AND RUMORED PILOT, WITHOUT WHOM I WOULD NEVER HAVE BECOME
AN ARTIST, DISREGARDING HIS BEST-LAID PLANS.

CONTENTS

DERMAPTERA, MANTODEA, ORTHOPTERA, AND BLATTODEA
EARWIGS, MANTIDS, CRICKETS, AND COCKROACHES

DIPTERA
FLIES

LEPIDOPTERA, ODONATA, AND NEUROPTERA
MOTHS, LACEWINGS, DRAGONFLIES, AND DAMSELFLIES

HEMIPTERA
TRUE BUGS, CICADAS, AND HOPPERS

HYMENOPTERA
BEES, WASPS, AND ANTS

PREFACE

No matter how vigilant we are in our efforts to keep nature on the outer side of our window-panes, insects will find ways into our homes. These little (and sometimes not so little) invaders are natural products of our own occupation of their habitat as we expand our subdivisions to the outskirts of towns. Through microportraits of locally found insects and other arthropods, this book offers an anthropomorphic presentation of our closest, often invisible, cohabitants—an invitation to consider the evidence of humans' impact on the landscape as we constantly redraw the boundaries between us and the natural environment.

The origins of this project can be traced to my interests in historical natural science collections. In Florence, Italy, across the river Arno from the main tourist attractions of Palazzo Vecchio and the Hard Rock Café, there is a rare, eighteenth-century collection of taxidermic animal specimens. This collection gradually grew out of the Medici family's private assemblage of natural objects acquired through generations of trade and colonial exploits, and is now housed in La Specola, or "The Observatory"—the oldest public science museum in Europe. Indeed, one of the earliest animal specimens is a pygmy hippopotamus that started life as a Medici family pet, living in the adjacent Boboli Gardens in the seventeenth century.

Walking through La Specola for the first time in 2011 while teaching a photography course, I could not escape an eerie sensation, imagining a less-than-ideal transformation from a live animal into a prepared "mount." The early taxidermy preparators worked from field notes and sketches, often misinterpreting animal anatomy, attempting to fill the skins with straw or

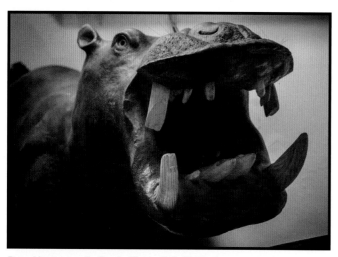

Pygmy hippopotamus, La Specola, Florence, Italy, 2015 DANIEL KARIKO

clay to full volume. Preservation was a common problem as well. Quite regularly, taxidermists were unable to stop the decomposition process or prevent insects from gnawing on fur and feathers. This resulted in a collection of bizarre creatures, some barely recognizable as specimens of their species.

In rooms lined with glass cabinets encasing animals that followed me with glass eyes, I experienced a singular notion. I was distinctly aware of the grotesque condition of the mounts, yet at the same time cognizant of the fact that these once were breathing, moving animals. This dichotomy of attraction and repulsion only served to feed my fascination for the place.

Contemporary museums of natural science are not essentially different from La Specola. The educational content is still presented through an environment of dioramas populated by taxidermy specimens. This nature analog is meant to absorb the attention of patrons, transporting them into the idealized version of the represented habitat. In a way, it's a mediated depiction of nature, a document, much as a photograph is said to be a representation of reality.

As an artist and a photographer, I am compelled by these intersections between real and designed landscapes. By blending reality and fiction, museum dioramas venture into a realm of

hyperreality—yet they are "too perfect" in their rendition of nature. The blemishes of the outdoors are removed in these curated, artist-created displays, which therefore represent an idealized, artificially flawless version of nature. As humans become more urbanized and enjoy less and less of real nature, we replace our notion of wilderness with this fictional version.

Consequently, rather than photographing untouched landscapes, I became more interested in constructed and man-altered ones, for their implied visual investigation of the human condition. In a similar way, my portraits of arthropods are a slightly fictionalized and anthropomorphized version of their natural selves.

I've always enjoyed being an amateur naturalist. My first toy microscope, a gift from my grandparents, provided hours of staring through the ocular at a rarified world of found specimens. Whether it was my parents' encouragement to study sciences, or simply my fascination with a variety of muddy things from the banks of the Danube, I felt comfortable collecting, dissecting, and absorbing visual information.

The subject of this book came about in a quite serendipitous way. In 2010 I moved to North Carolina to take on a position as an assistant professor in photography at East Carolina University School of Art and Design. My move came on the heels of several years in Florida, where I spent time photograph-

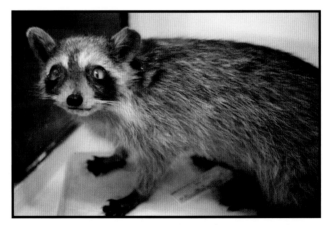

Raccoon, La Specola, Florence, Italy, 2015 DANIEL KARIKO

ing the failed real estate developments full of asphalt cul-de-sacs, devoid of any homes, and surrounded with scrub brush and palmetto plants. The irony of moving away from Florida only to rent a suburban home on a street ending with a cul-de-sac was undeniable.

Much like the places I photographed in Florida, our rental home was on former agricultural land, a subdivision so new that Google Earth still depicted it as an empty field. This recent shift from rural to suburban meant that the surrounding nature was still transitioning from a field to asphalt, along with the creatures that found themselves thrust amidst this suddenly changing environment. I observed a pattern across places, times, and situations whereby humans unapologetically imposed their preferences and agendas on nature.

I started collecting arthropods I found in and around our new home in an effort to somehow describe the relation of this landscape to the subdivision that landed, a few months earlier, like an alien spacecraft on top of it. My first finds were Dermestid beetle larvae roaming like microscopic sheep through our bathroom in search of loose organic fibers and dead skin flakes. I took them to a microscopy lab in the Biology Department on the East Carolina University campus in hopes of making some images. I posed them, first under a stereoscopic microscope,

Crow diorama, Sharjah Natural History Museum and Desert Park, Sharjah, United Arab Emirates, 2016 DANIEL KARIKO

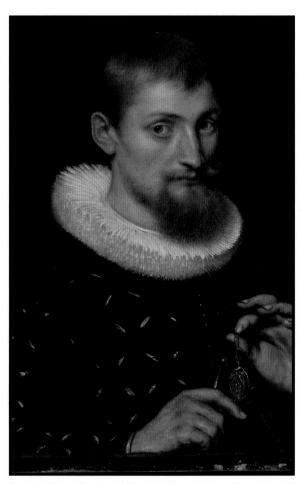

Peter Paul Rubens, Portrait of a Man, Possibly an Architect or Geographer, 1597

using forceps and needle tools. In a miniature version of a photography studio, they were lit with LED lights and tiny reflectors. After that, they were transferred into a scanning electron microscope for the final imaging. Pretty soon, I was setting out to make portraits of all of my found semi-invisible neighbors.

I found arthropods—the majority falling into the group of insects—dead and alive, in my window screens, on sidewalks, or stuck in the grill of my car. They were not invading our suburban environment, but quite the opposite: we were the ones parceling and boxing up their natural habitat.

I drew inspiration for lighting, angle, and crisp detail from my love of the Flemish and Dutch Renaissance and Baroque painters like Jan van Eyck, Peter Paul Rubens, and Johannes Vermeer. My approach further individualized the portraits and gave them anthropomorphic quality. With these images, I aimed at a

balance between strange and familiar in an effort to retain the relationship with both art and science.

There's an urgency to this project, too. Most species of insects are likely to disappear before they are even discovered and described by entomologists. Our planet is home to an estimated five, perhaps ten million different kinds of insects, not including other arthropods. Most scientists agree that fewer have been identified so far than remain to be discovered. It is estimated that insects constitute 80 percent of all the species in the world. And yet, in spite of their numbers and variety, they are vanishing at an alarming rate, from newsworthy bee colony collapses to a recent noticeable absence of dead insects on our windshields. The population of some species has fallen by 90 percent in the last twenty years. Because they are not charismatic megafauna, theirs is a silent extinction. It is an elimination from the natural record, caused by habitat loss, pesticides, herbicides, and climate change, that is invisible to the average person.

The muses in this book are depicted through the words of Tim Christensen and the illustrations of Isaac Talley. These portraits are an attempt to put you face-to-face with some of the most common of your tiny neighbors, and share their beauty, character, otherworldliness, and intricacy.

DANIEL KARIKO
DECEMBER 2018

ALIENS AMONG US

FLIGHTLESS ARTHROPODS

MYRIAPODS, ARACHNIDS, ISOPODS, AND SILVERFISH

The Crawlers

These leggy arthropods can easily be overlooked.
Wingless, they sneakily crawl and climb, hiding in the cracks
in a wall, under forest litter, or under folds of skin.

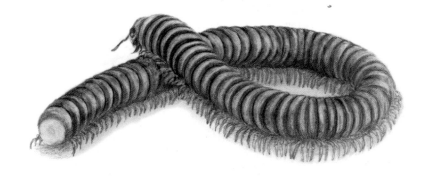

Millipede

Translating to a "thousand feet," Myriapods don't have quite that many legs. These long creatures evolved over 440 million years ago and are more closely related to lobsters than insects. The ones in your home are harmless and like to eat decaying leaves or rotting fruit. In the wild you might run into a more colorful species that will cover you in cyanide poison if you are too rough with them.

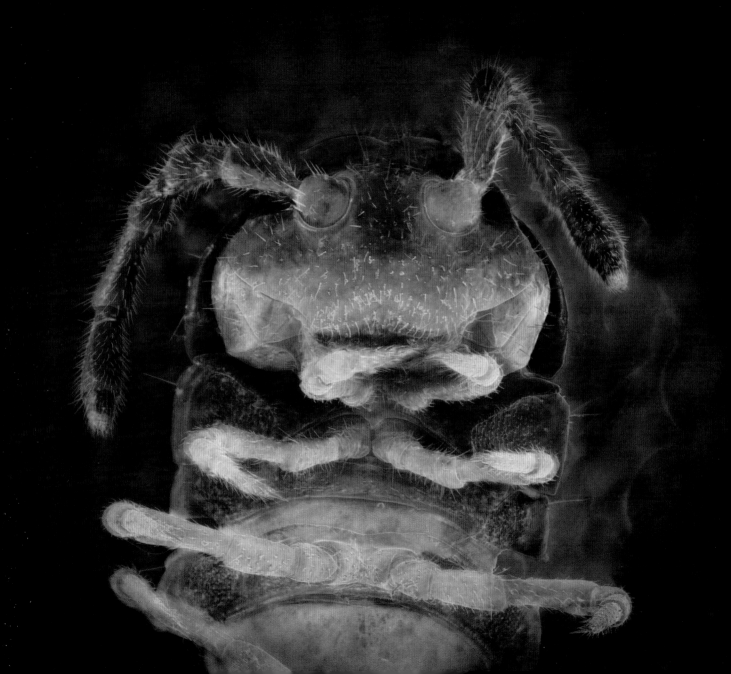

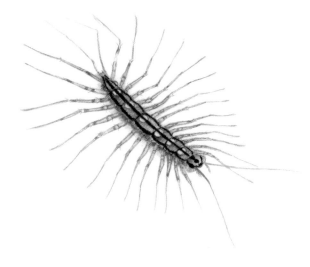

House Centipede

Though Centipedes are in the same order of arthropods as Millipedes (Myriapoda), they are predators, always on the prowl in your home for roaches and other insects to eat. Their first few legs are modified to inject venom into their prey, while the back legs are longer so as to beat and lasso their meal into submission. They are the stuff of nightmares, with the ability to dash out quickly from dark crevices. Fortunately, those leg-fangs don't have enough force to easily pierce human skin.

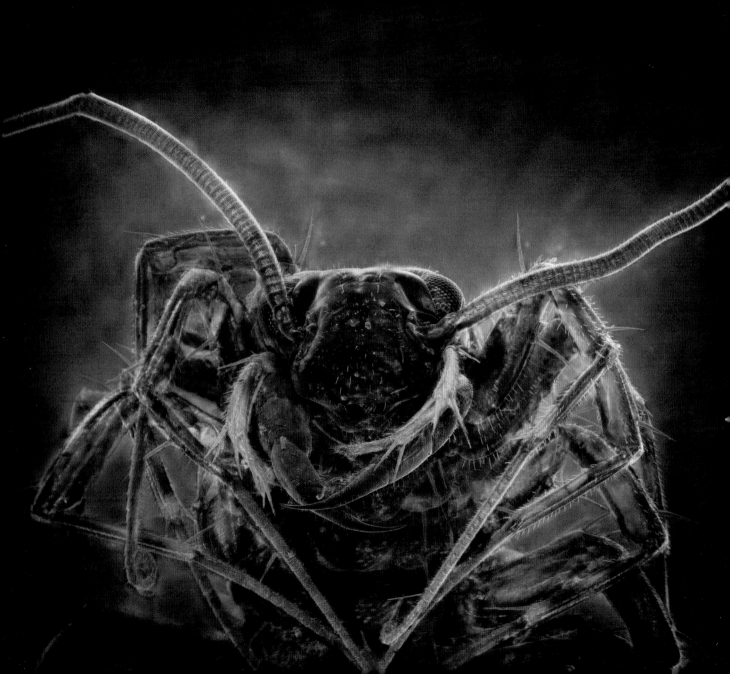

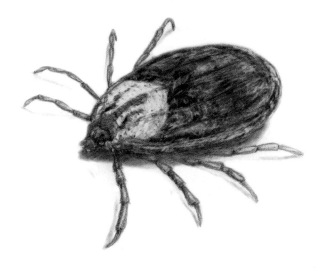

Tick

These spider relatives are old and likely plagued the dinosaurs. They find vegetation along well-used paths, where they reach out with their first few legs to grab hold of a host that happens by. Once attached, they will open their mouth, using their head to impale the host, and feed for days, swelling with blood until they drop off to molt and grow bigger or lay eggs. The most ticks recorded on an animal was 50,000 on an unfortunate giraffe. For some ticks, one meal can hold them over for years.

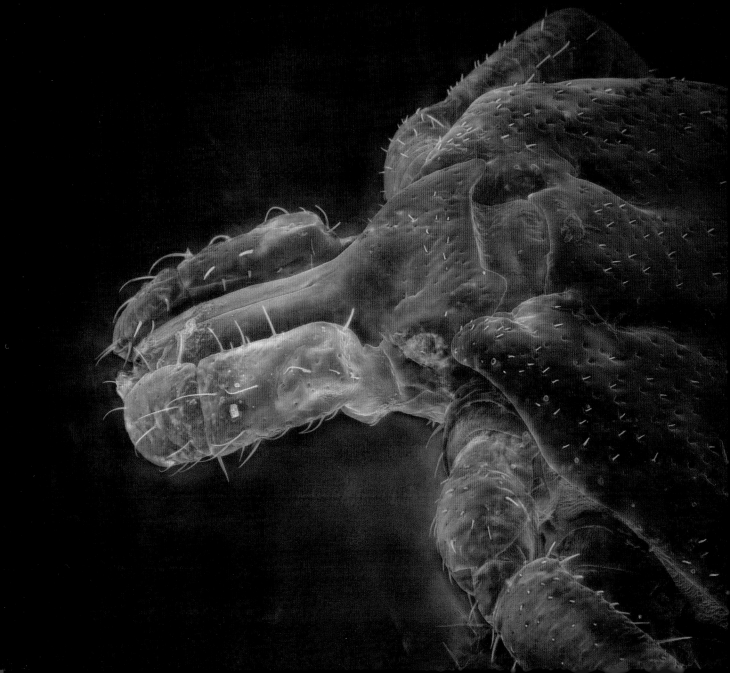

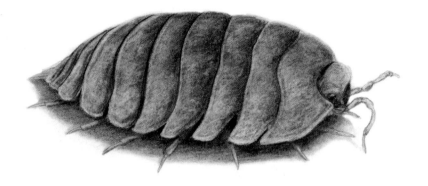

Pillbug

These terrestrial crustaceans (Isopods) are also known as roly-polys or woodlice. Often found in humid environments, they have gills like their shrimp relatives and are very susceptible to drying out. Females have a pouch on their underside where their eggs will hatch; the young will grow for a few days before going on their way as harmless detritivores, eating rotting vegetation.

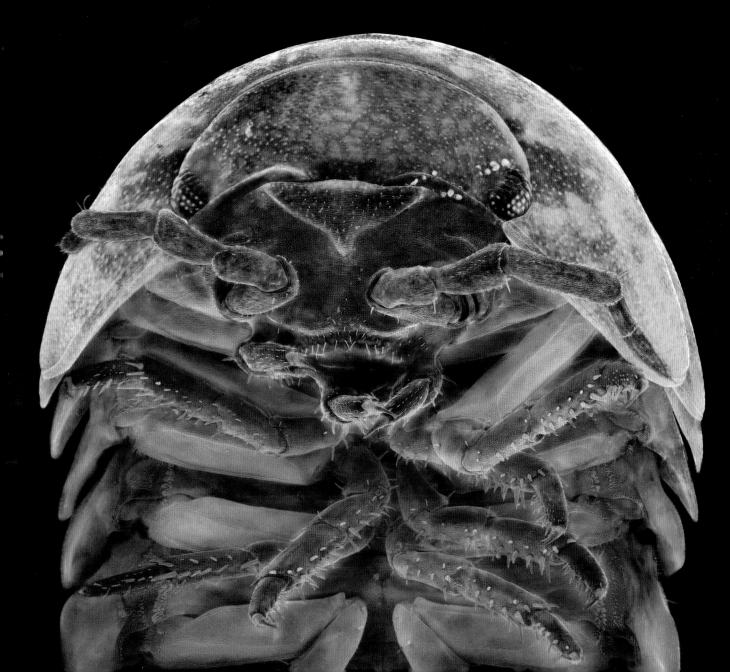

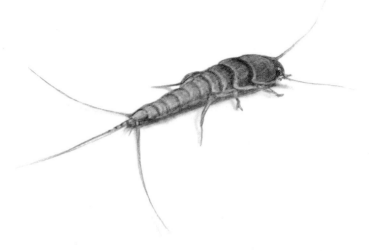

Silverfish

Silverfish are in the order Thysanura and have been around for over 400 million years. They have silvery scales that will break off in a predator's mouth and the ability to regrow any lost appendages. They're known for lurking in damp places, feeding on any bits of sugary food or book binding they can find. They are prone to elaborate dancing, which they indulge in during mating rituals: males perform to entice females to pick up their sperm packets, and females dance just before laying their eggs.

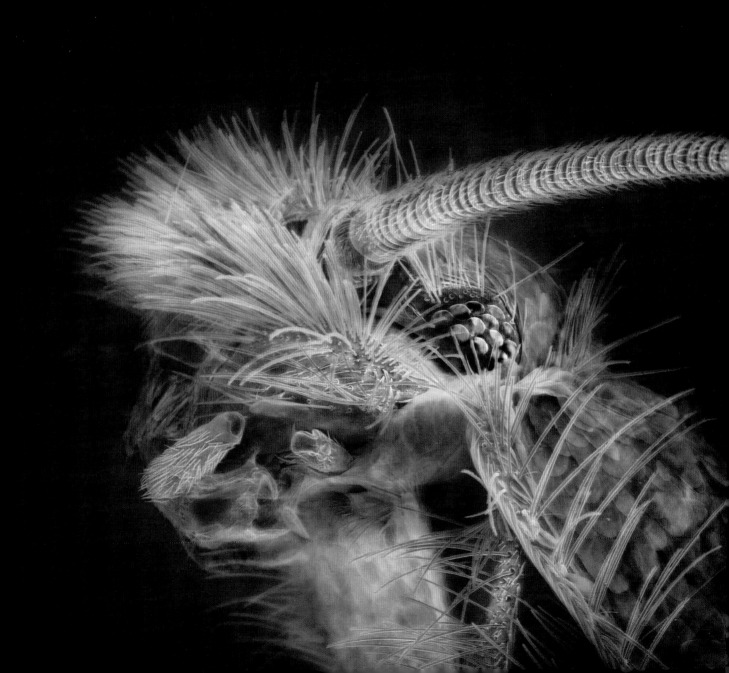

COLEOPTERA

BEETLES

The Conquerors

With wings tucked neatly under an extension of the exoskeleton
(called the elytra), Coleoptera can fly to the far corners of whatever
habitat they prefer. Beetle larvae will feed on almost anything,
an ability that has allowed this group to radiate into more
niches than any other described order of insects.

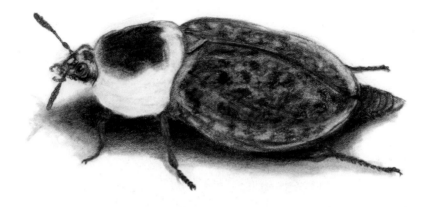

American Carrion Beetle

Following the faint smell of rotting flesh, these beetles can find a corpse within hours of its death. First, they quickly devour any competing fly maggots that have hatched, bringing with them an army of mites to mop up and eat any that remain. They will defend the corpse as it decays, laying their own eggs and secreting nasty-smelling chemicals to deter other competitors. Forensic scientists can use the life stages of these beetles to accurately determine a time of death.

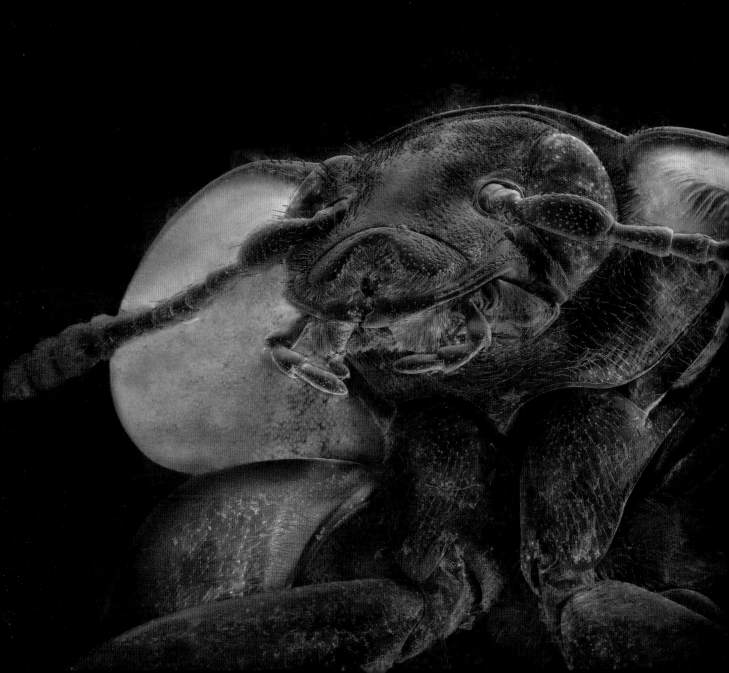

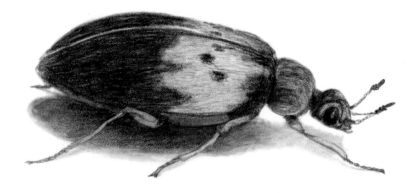

Dermestid Beetle
These Dermis (skin) Beetles feed primarily on dead skin and hair. They are one of the few insects that can break down keratin fibers. With each human shedding around 1.5 pounds of skin a year, there is no shortage of food in your home for these insects. In fact, some museum curators and taxidermists use them to clean skeletons for display.

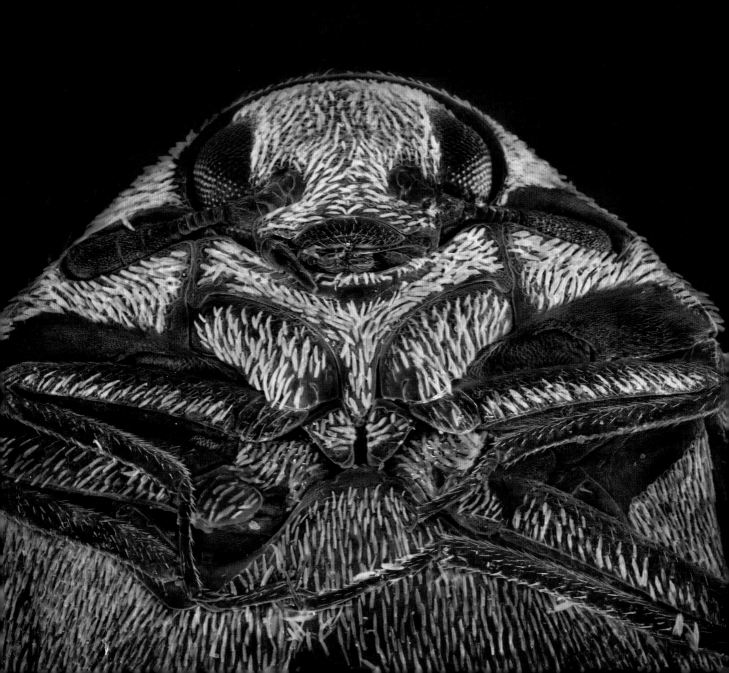

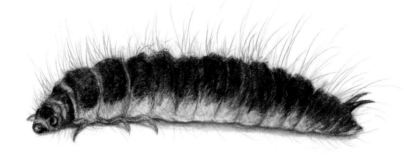

Dermestid Beetle Larva

This tiny elongated spiky ball is the larva of a carpet beetle. You will rarely see these well-camouflaged insects, also known as Larder or Leather Beetles, cruising around the floor. As they roam at night, the hairs that cover them are a mouthful that most predators will avoid. These are some of the insects most feared by entomologists, because their favorite food is insect collections. An infestation can reduce a collection to dust in a matter of weeks.

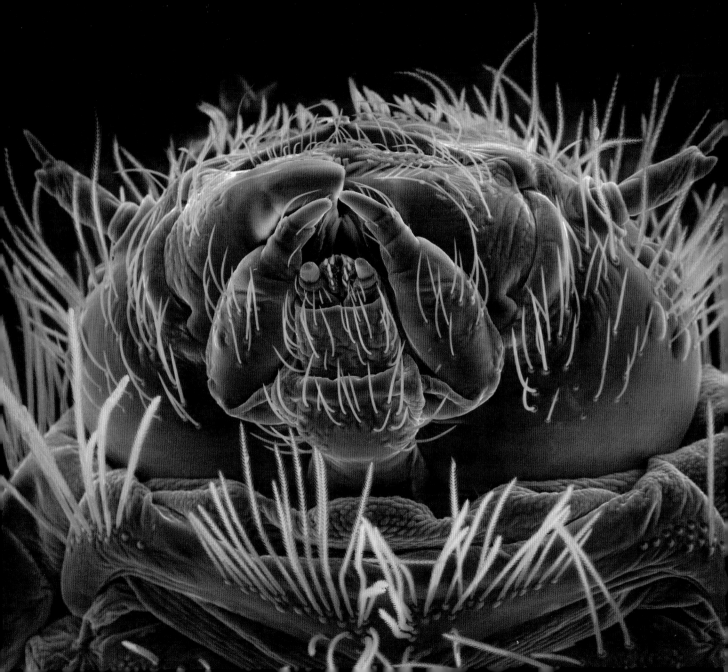

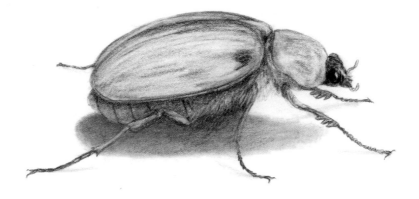

May Beetle

These clumsy beetles are the ones that bash into your outside lights at night. Adults hide underground all day, waiting for the cover of darkness to feed on vegetation in your yard. Their larvae stay below, feeding on roots for two to three years before emerging as adults. You can locate them by carefully watching robins in the spring; they cock their heads side-to-side listening, then pierce the ground and pull up the grub in their beaks.

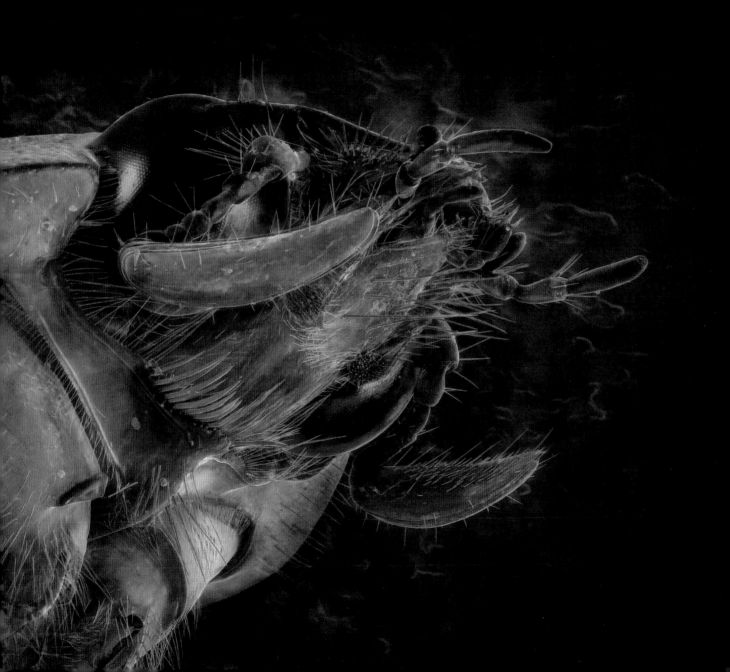

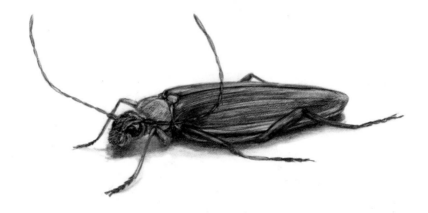

Long-Horned Beetle

Long-Horned Beetles often have strikingly long antennae. These widely spaced olfactory organs give them a superb sense of "smell," allowing them to find mates, food, and rotting wood. Females use their strong chisel-like mandibles to chew into trees where they lay their eggs. The larvae hatch and bore holes throughout the wood until they pupate. When they emerge as adults they use those same mandibles to create exit holes in the sides of trees.

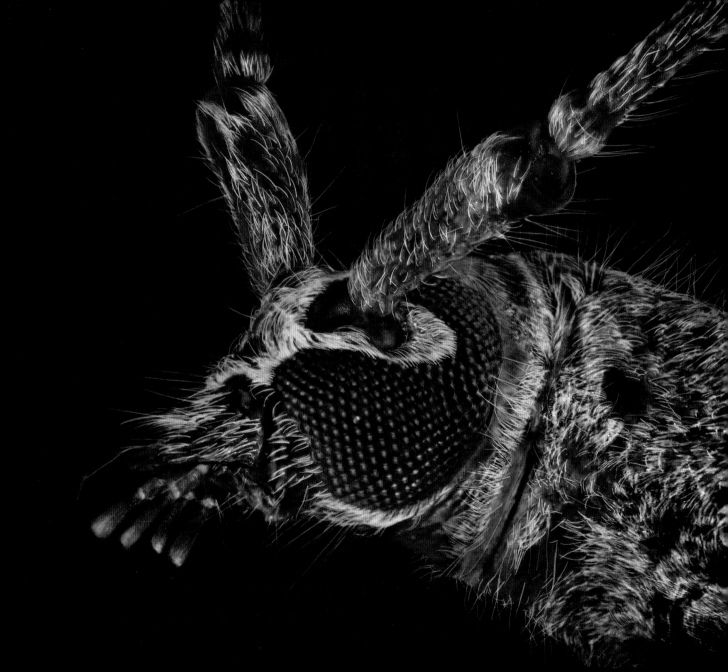

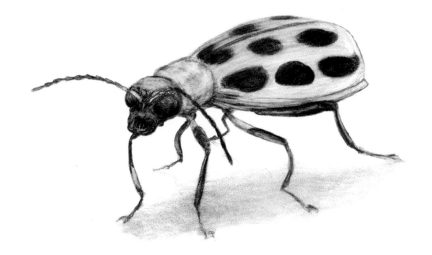

Spotted Cucumber Beetle

Bad news for the garden. These beetles will tear through the leaves of your favorite plants and wilt them with their gut bacteria. Those in the larval stage burrow into the soil, homing in on the roots, which they hollow out with a voracious appetite. The larvae then pupate and turn into adults, starting the cycle all over.

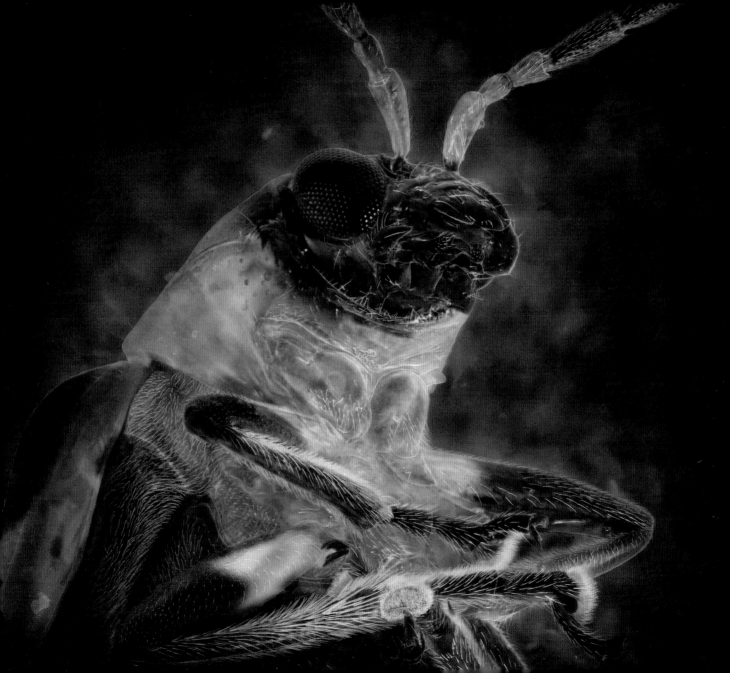

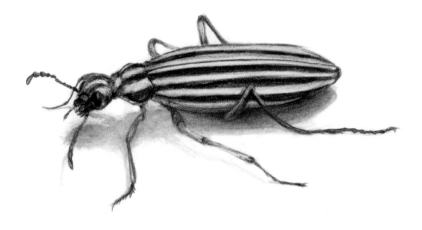

Blister Beetle

If attacked, these beetles spray burning poison from their abdomens. Male Blister Beetles gift this poison to females to help protect their eggs from predators. This same substance has been used by humans as an aphrodisiac; also known as "Spanish flies," Blister Beetles have been banned in many countries because of numerous deaths associated with their ingestion.

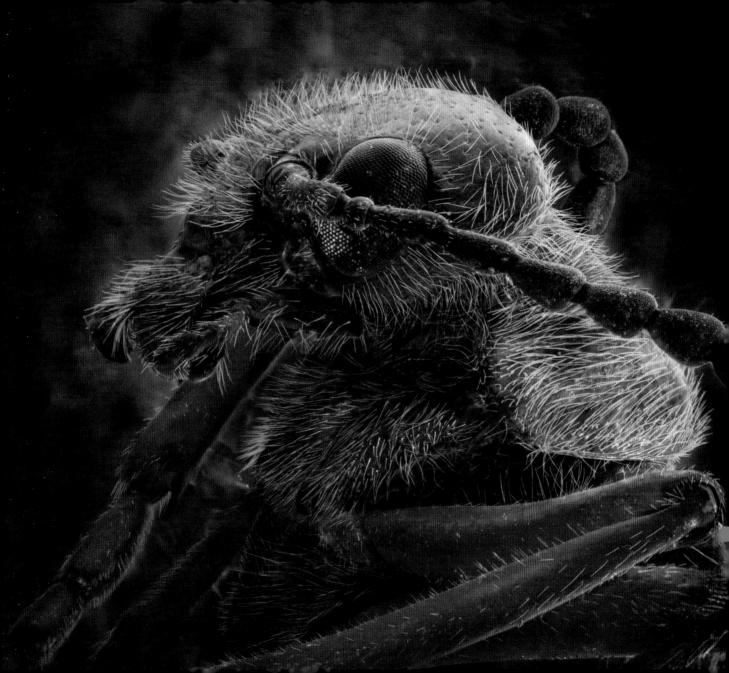

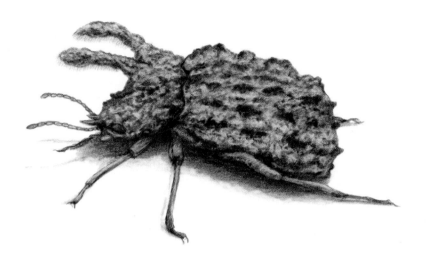

Forked Fungus Beetle (MALE)

These beetles are small tanks living exclusively on shelf fungus. Their superstrong exoskeleton and horns are important for males in fending off other males that try to steal their fungus or interrupt mating. As tough as these beetles are, they will play dead the instant you try to pick them up. Once they sense your hot mammalian breath they will exude a nasty-smelling fluid from their abdomen that they have derived from the fungus.

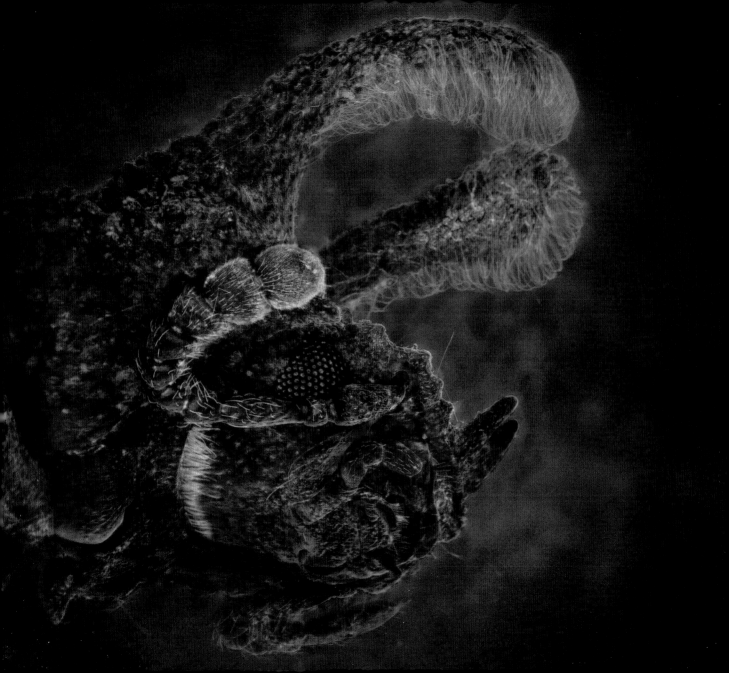

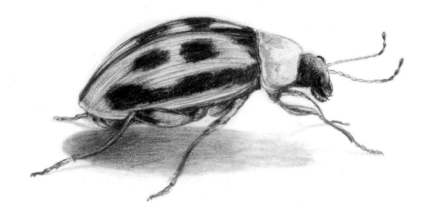

Bean Leaf Beetle

These small beetles really do love beans. They spend all their life stages eating, living, and mating on bean plants. The larvae are relegated to the roots below while the adults dine in style on the leaves and legumes above. While their damage to crops is usually mild, they can spread plant viruses potent enough to decimate a field of soybeans.

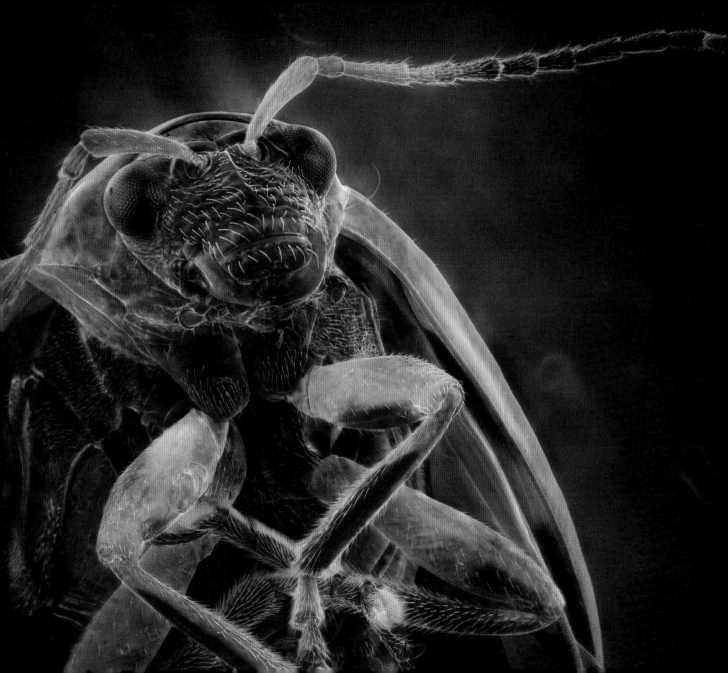

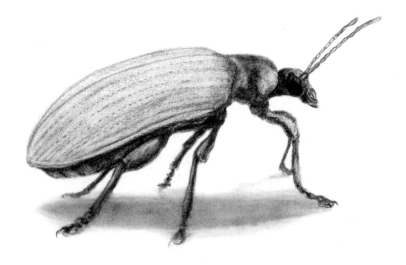

Three-Lined Potato Beetle

These beetles prefer tomatillos but will also be found feeding on potatoes, peppers, eggplant, and tomatoes. They are very toxic and accumulate poisons from the plants they eat. The larvae are especially careful in protecting themselves, covering their bodies in their own excrement to deter predators. Scientists call this a "fecal shield."

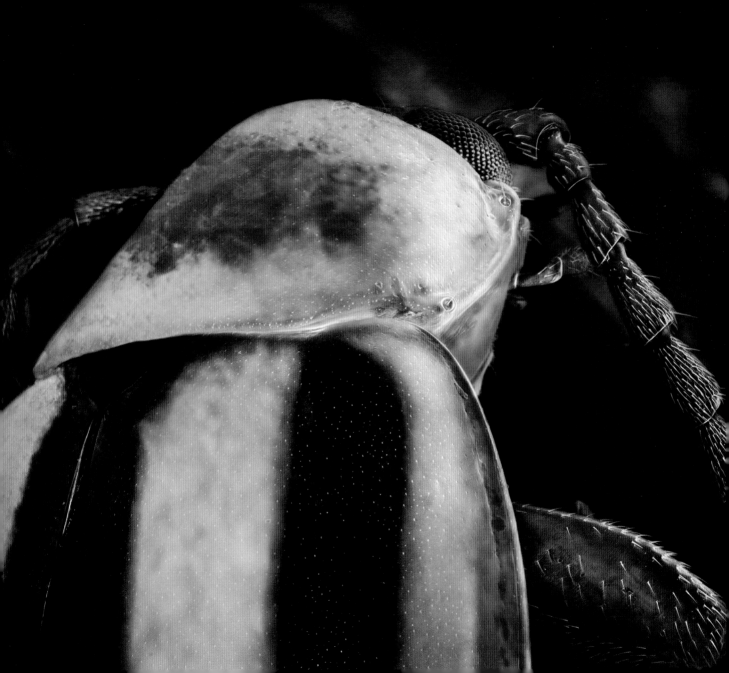

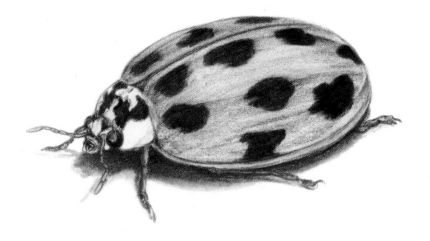

Multicolored Asian Lady Beetle
Often exist-
ing in packs of millions, aphids—small insects that suck the juices out of tender plants—
can destroy whole fields of crops. To control these pests, farmers imported Multicolored
Asian Lady Beetles, which can consume on average fifty aphids per day. When the days
grow colder the beetles congregate in the thousands on the light-colored, south-facing
walls of homes in the northern hemisphere. If they find a good place they will leave
scents for next year's beetles—a kind of olfactory five-star review for the lodging.

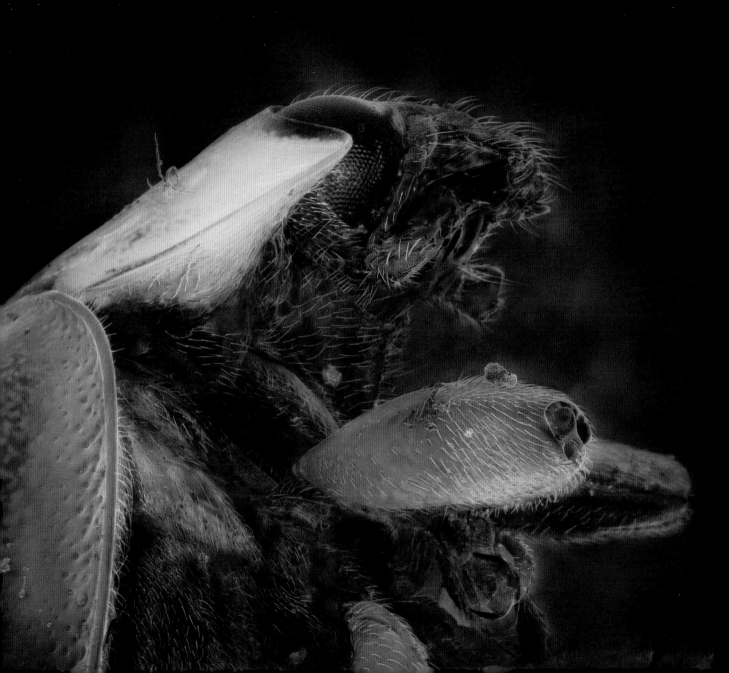

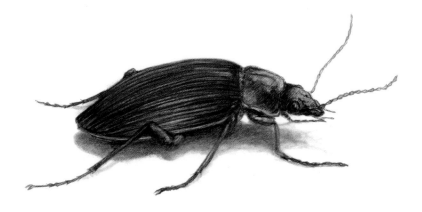

Ground Beetle

There are more than 40,000 species of ground beetles worldwide, making them one of the most common types of beetle. These formidable predators typically have long, quick-moving legs, which they use to chase down other insects before dispatching them with powerful jaws. Some species choose not to run, and instead specialize in eating snails, slugs, or caterpillars.

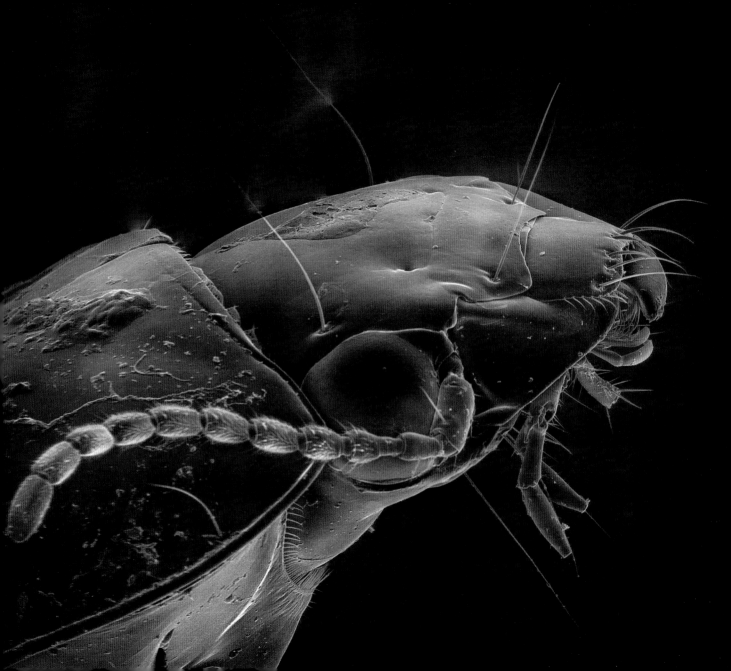

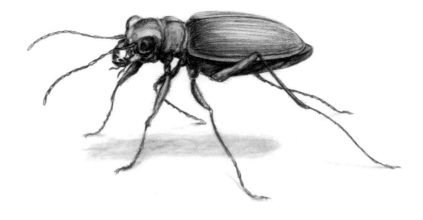

Tiger Beetle
These types of ground beetles have massive jaws and move at spectacular speeds. Covering the ground at up to 5.6 mph, they chase down nearly any insect they want to eat. In proportion to average human height you'd be able to reach speeds of 500 mph if you were as fast. Their slower-moving larvae dig long vertical burrows. With their jaws just at the surface and covered in sensitive hairs, they flip out of the burrow to grab unsuspecting victims.

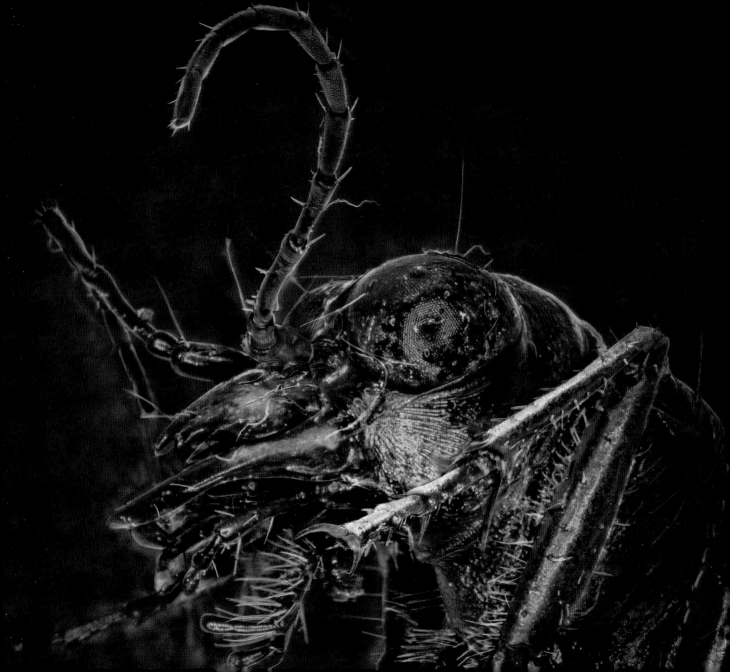

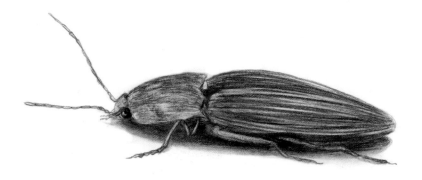

Click Beetle

These harmless, elongated beetles use a startling trick when a predator grabs them. A spine and notch on the underside of their thorax produces a violent snapping motion that makes an audible click. Pick one up and it will try to pop right out of your hand. Place it on its back and it will snap up into the air, land on its feet, and scurry away.

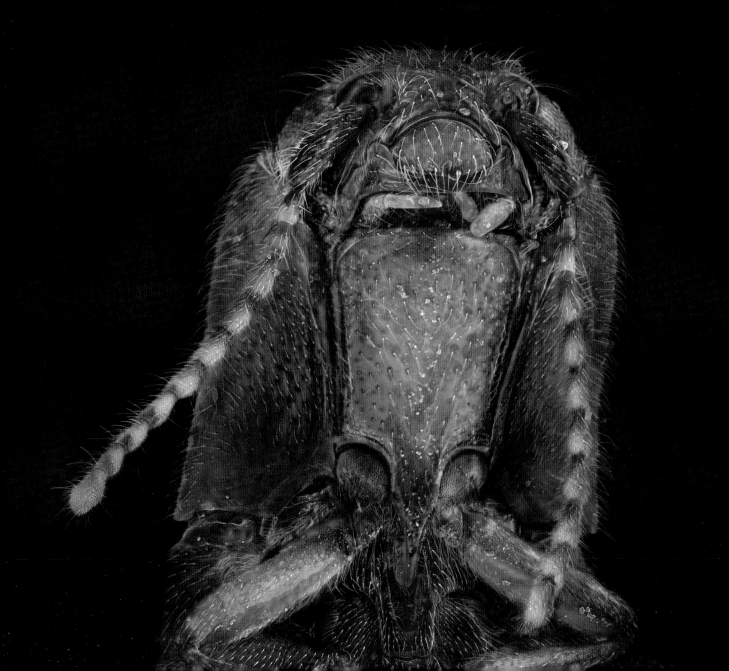

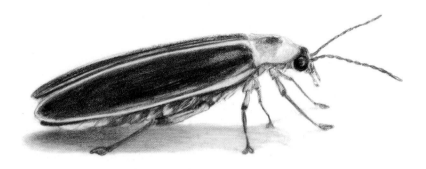

Big Dipper Firefly

Despite the suggestion of their name, Big Dipper Fireflies are beetles. Lighting up warm summer nights in the eastern United States, they put on a dazzling show. Males light up their abdomens and make a swooping "J" signal to entice females to respond with a flash of their own. Once seen, males approach females with caution, as the male of a different species of predatory firefly might pretend to be a waiting female. Instead of mating, a male might find himself devoured.

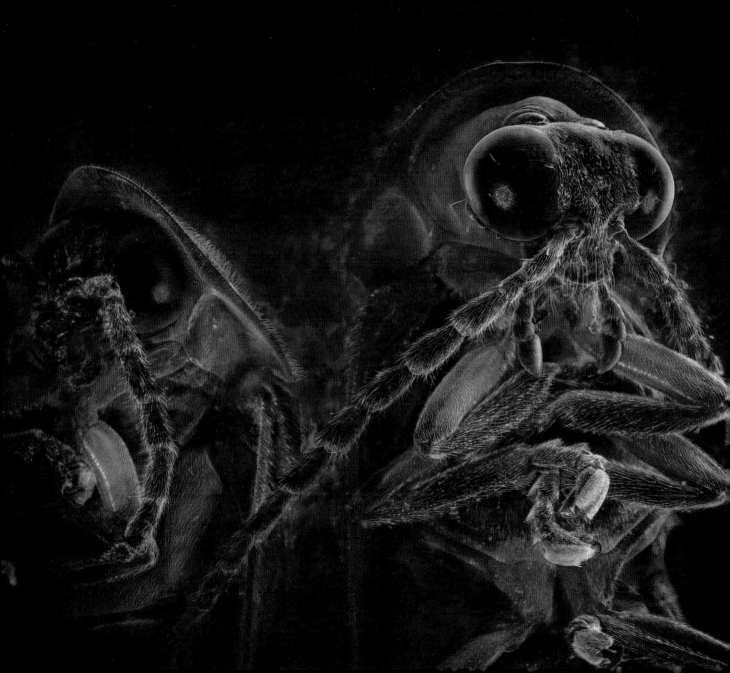

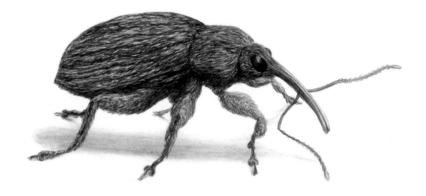

Boll Weevil
Weevils are also known as Snout Beetles, as their mouthparts are modified into a multipurpose snout with a mouth at the tip. They use this strong structure to bore into hard seeds and other vegetation, where they will create a feeding hole or a place to lay an egg. Females are careful to lay only one egg on each piece of grain or nut so that their offspring don't compete for a meal.

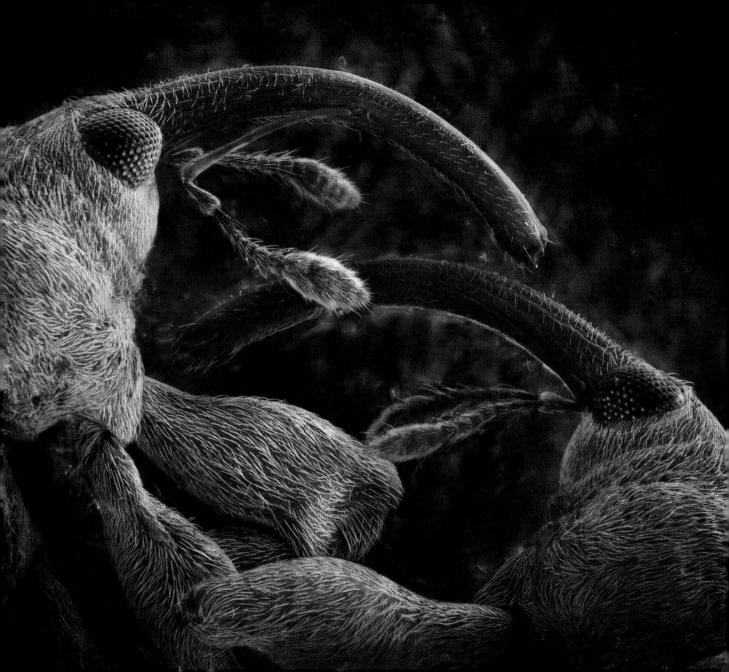

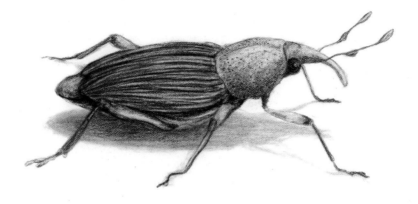

Dryophthorine Weevil
Weevils are specialists. Some are found only on a single species of tree. There are estimated to be more than 40,000 types of weevils on earth with most unknown to science; any given species of plant on the planet likely has at least one weevil species that calls it home. It is estimated that up to one-third of all stored grains on earth are destroyed by these seed-eating insects.

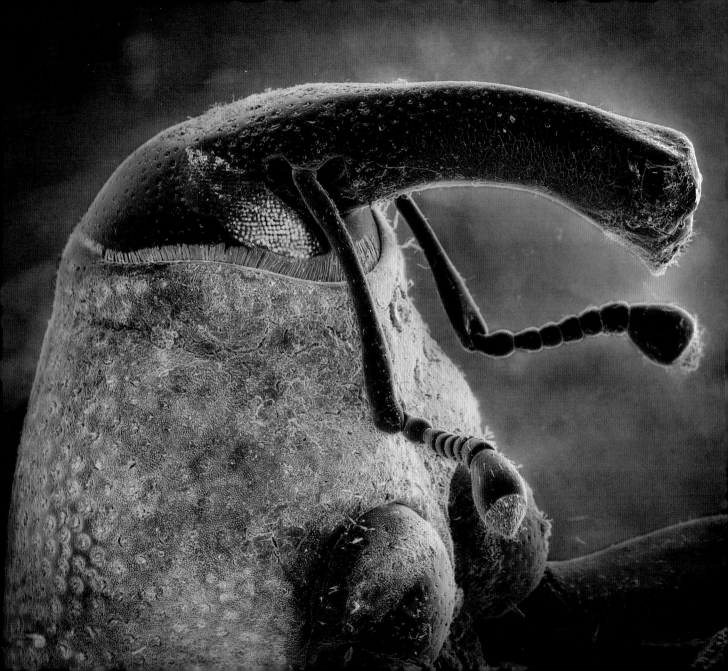

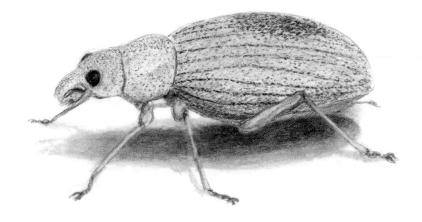

Green Immigrant Leaf Weevil
Like many people in North America, this species immigrated through New York in the early 1900s. Coming over from Germany, the Green Immigrant Leaf Weevil found a continent wide open with opportunity and spread all the way west seeking new foods and new homes. Its distinctive green scales help it remain camouflaged and will break off into the mouths of would-be predators.

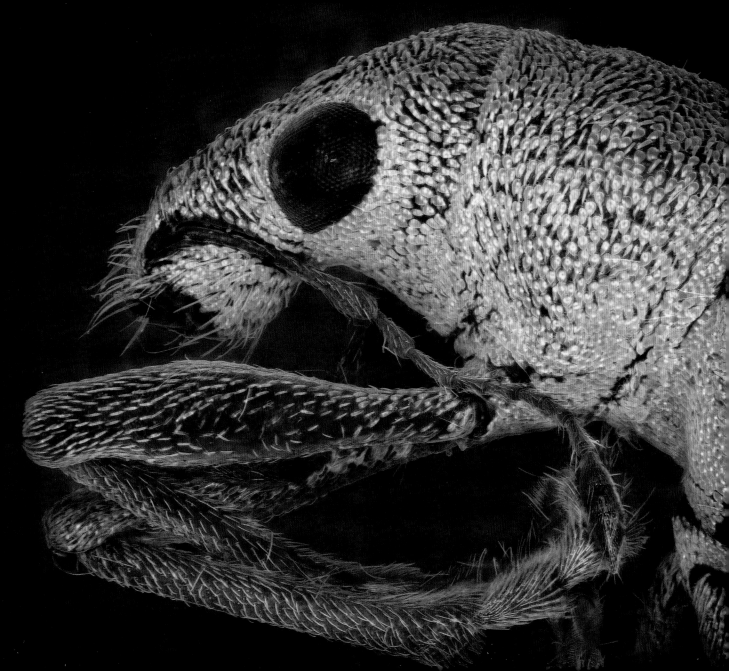

DERMAPTERA, MANTODEA, ORTHOPTERA, AND BLATTODEA

EARWIGS, MANTIDS, CRICKETS, AND COCKROACHES

The Creepers

Though all members of these orders have wings,
they are rarely utilized. Awkward in the air, these creatures are
easily picked off by predators. Most will be found in and around
your home only at night, and close to water.

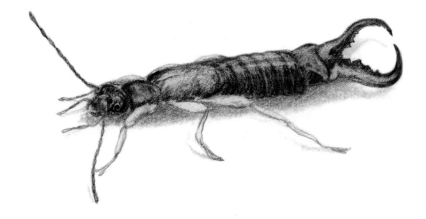

Earwig

The Earwig's name, combined with fierce-looking pincers, strikes fear into most. In truth, earwigs are harmless and full of surprises. That little pouch on their back is a set of expertly folded wings; and the pincer at their back end is for defense. They mostly eat decaying stuff lying around in damp places. They make great families, with some of the best parents in the insect world. The female will stay with and carefully clean her eggs once they are laid; once they are hatched, she will tend to her children's every need and defend them from predators. When she leaves to find food, the young get along with each other—they even share their meals.

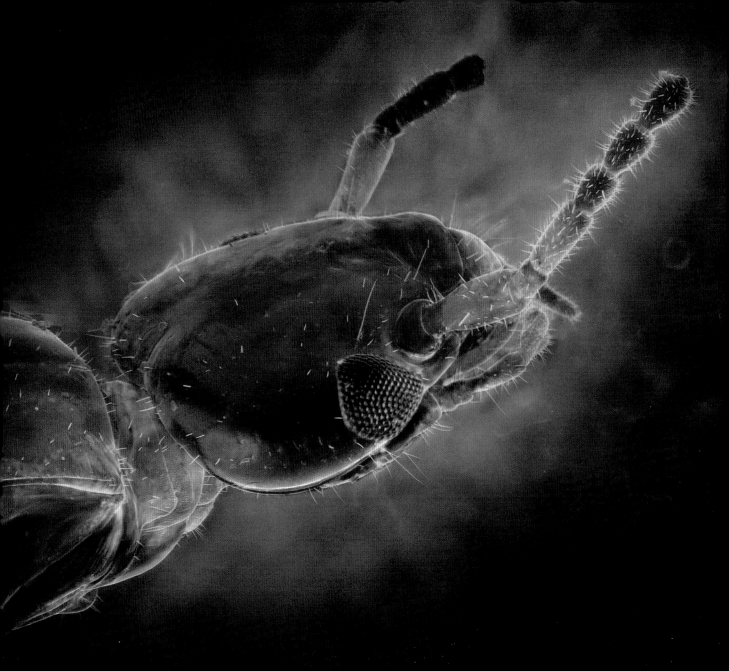

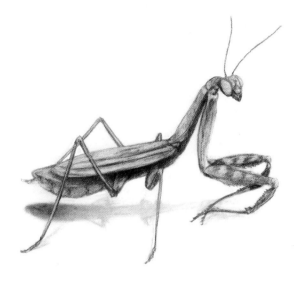

Mantid

Mantids (Mantodea) are vicious ambush predators, equipped with folded limbs that can streak out and grasp. Their triangular heads swivel to bring their super-high-resolution vision to bear on potential victims; once Mantids have snatched their helpless prey, they eat it live with their powerful mandibles. A Mantid's hunger begins early, when it erupts from its hardened egg mass (called an ootheca) to seek out small prey. When fully grown, some Mantids can eat small birds.

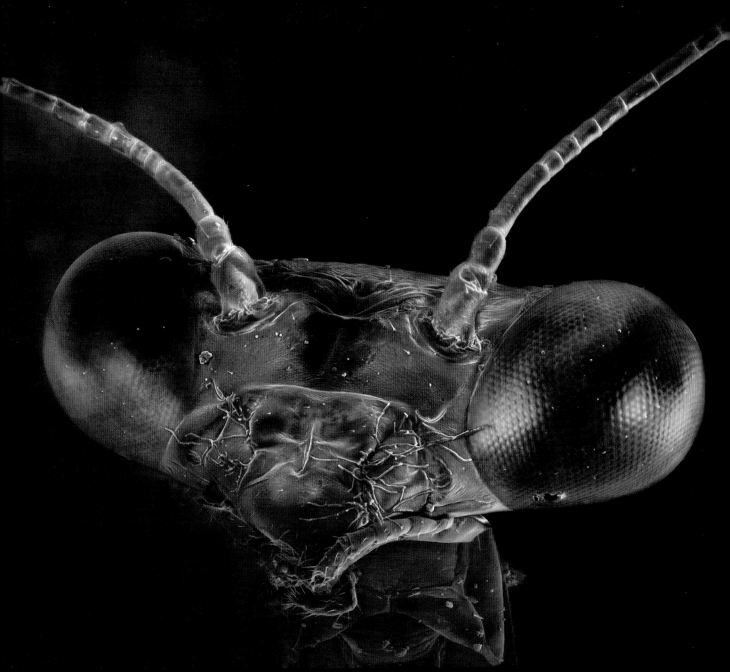

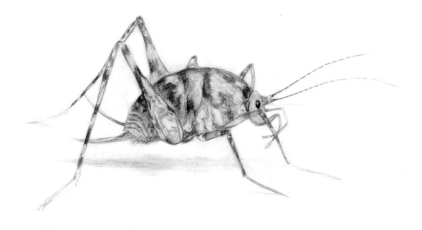

Camel Cricket

This relative of the grasshopper (Orthoptera) is often called a Cave Cricket. Living only in the dark, these spiderlike crickets feel their way around with antennae longer than their body. They are like the goats of the insect world and will eat anything they can find, including clothing. Unlike other crickets that jump away from danger, these crickets will jump toward you to scare you away. Be careful opening the door to that damp and dark crawl space.

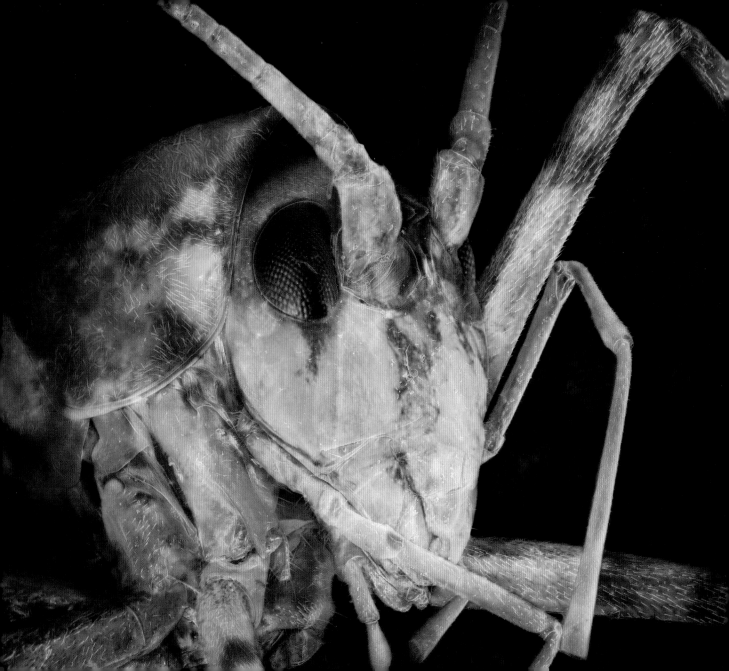

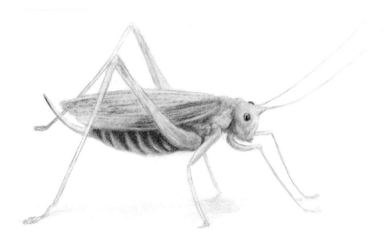

Green Tree Cricket

These crickets (Orthoptera) fill the trees with mating songs in the summer. Males will rub their rough wings together to make that distinctive chirping noise. You can tell the temperature outside by changes in the pitch of the male's song: it is higher when it is warm and deeper when it is cool. Music isn't all the males have to offer—they also have a special spot between their wings called the metanotal gland. During mating, females eat a sugary meal from this gland that helps them have the energy to lay their eggs.

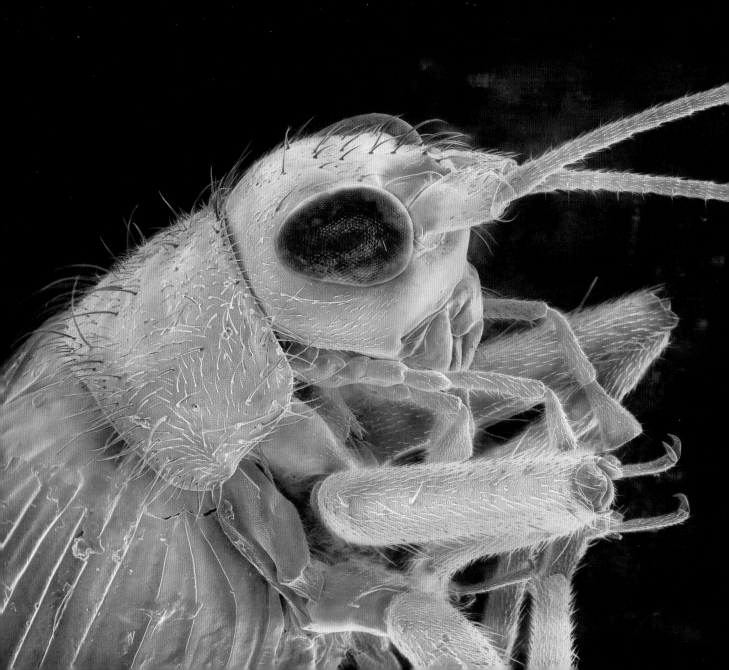

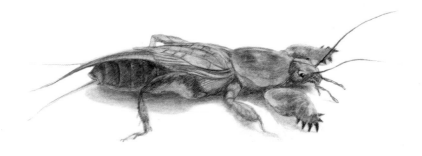

Mole Cricket

These crickets (Orthoptera) are the insect version of moles. They live almost entirely underground and have powerful shovel-like forelimbs for digging quickly. During mating season, the males are not only musicians but instrument builders. They will carefully dig out a chamber with two precise openings, each resembling an exponential horn like in some modern loudspeakers. At the base of these horns, a male will hollow out a resonance chamber where he will sit and sing for a female, shaking the ground with his sound.

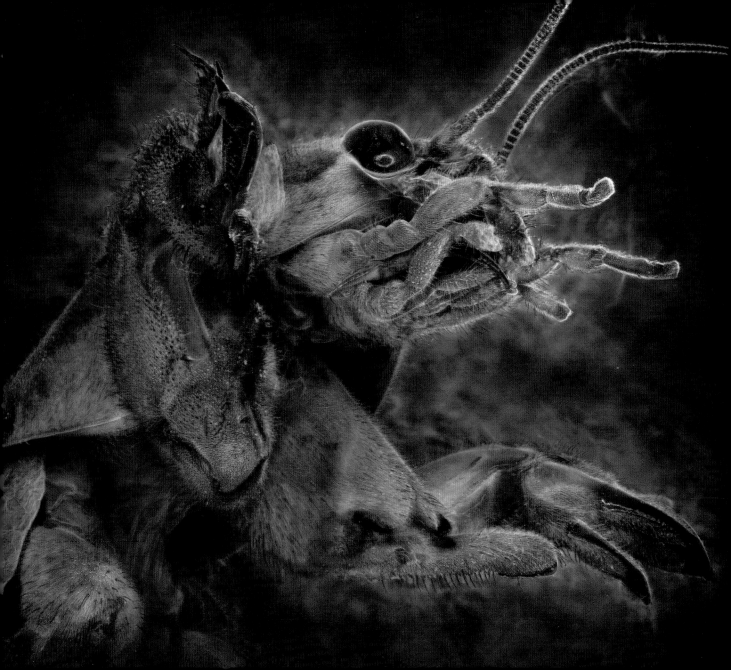

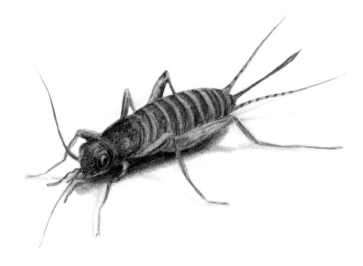

Scaly Cricket

This cricket (Orthoptera) has scales much like a butterfly. These scales will break off in the mouths of would-be predators. Members of this family are very keen on mating. One Australian species of scaly cricket holds the record for most frequent matings; one male was recorded copulating fifty times in three to four hours with a single female. She mostly thought his sperm was a convenient meal.

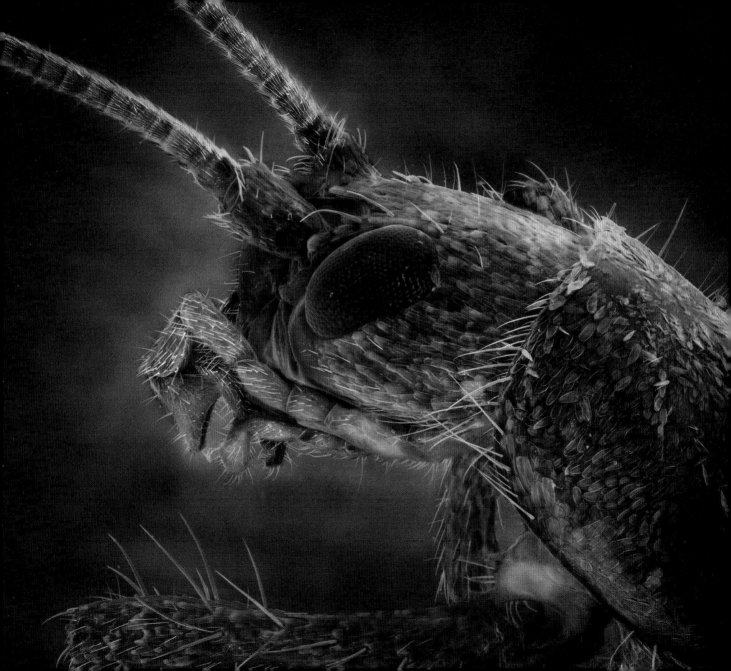

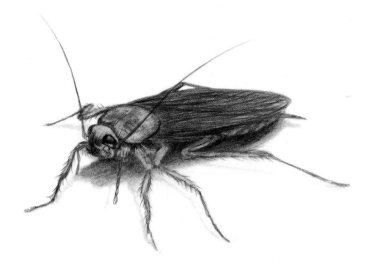

American Roach

An import from Africa in the 1700s, this is the largest of the common roaches. Known for their flattened bodies and long legs that allow them to quickly hide in any nearby crack, American Roaches can find a meal just about anywhere with their three hundred different taste receptors (humans have five). Through a process called parthenogenesis, a lone female can create a colony of new roaches that have all developed from unfertilized eggs. Yes, adults can fly.

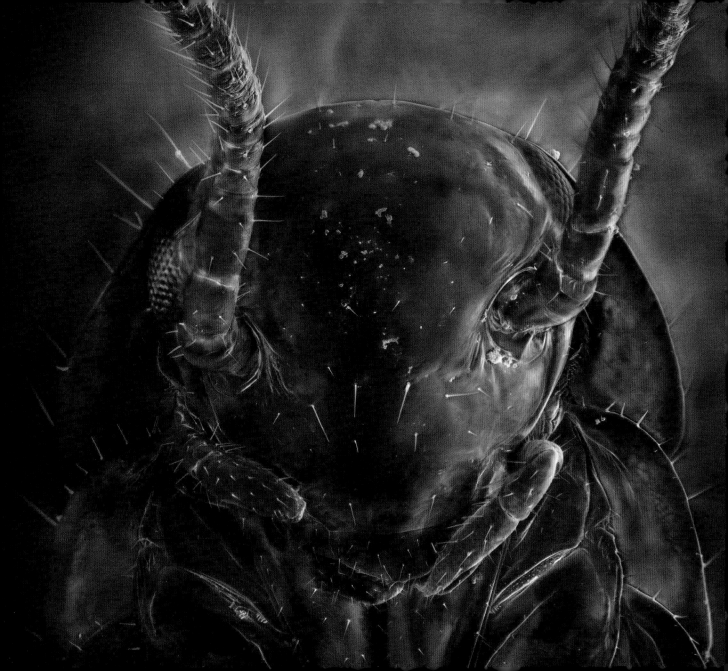

DIPTERA

FLIES

The Buzzers

Masters of the air, these insects have strong wings to
propel them forward. Unlike other orders, they also have gyroscopes,
known as "halteres," to help them perform incredible acrobatic
moves, thus avoiding predators or the swat of a hand.

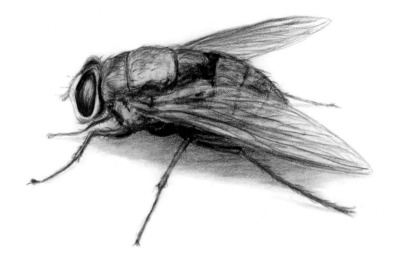

Green Bottle Fly

This very common fly has very uncommon uses for humans. Before the advent of antibiotics their larvae were used in "maggot therapy," in which they would eat away dead tissue, leaving healthy tissue behind. Nowadays this fly has another macabre use. Like the American Carrion, the Green Bottle Fly's ability to locate dead things quickly and its very predictable life cycle make it ideal in determining the time of death of any unfortunate animal, including humans.

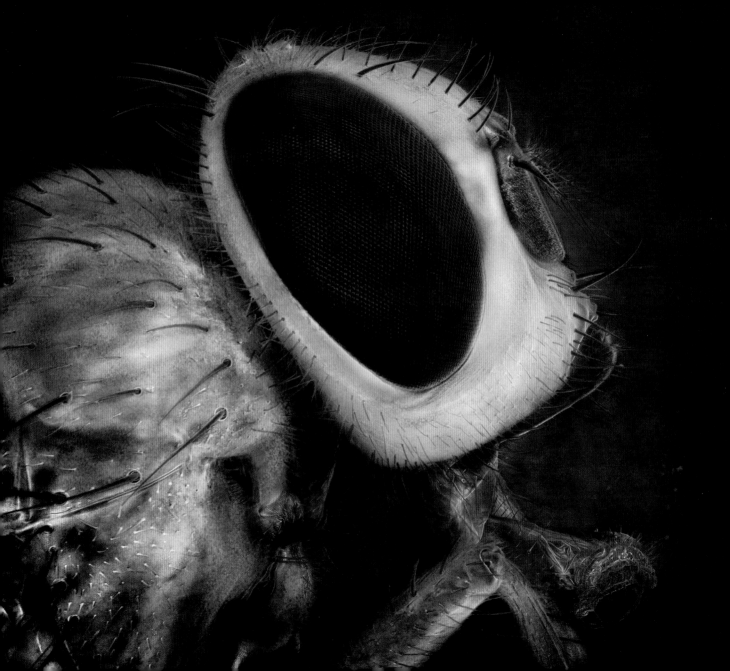

Yellow Soldier Fly (PTECTICUS FLY) These harmless flies

are good at keeping harmful disease-carrying flies at bay. They lay their eggs in rotting vegetation or decaying material, and their larvae voraciously consume much of the stuff before it begins to smell bad. Their quick eating prevents nasty species, such as Green Bottle Flies, from laying eggs. Soldier fly larvae are also one of the leading prospects for increasing the percentage of protein in animal diets, because they can convert animal waste into high-protein, high-fat animal feed.

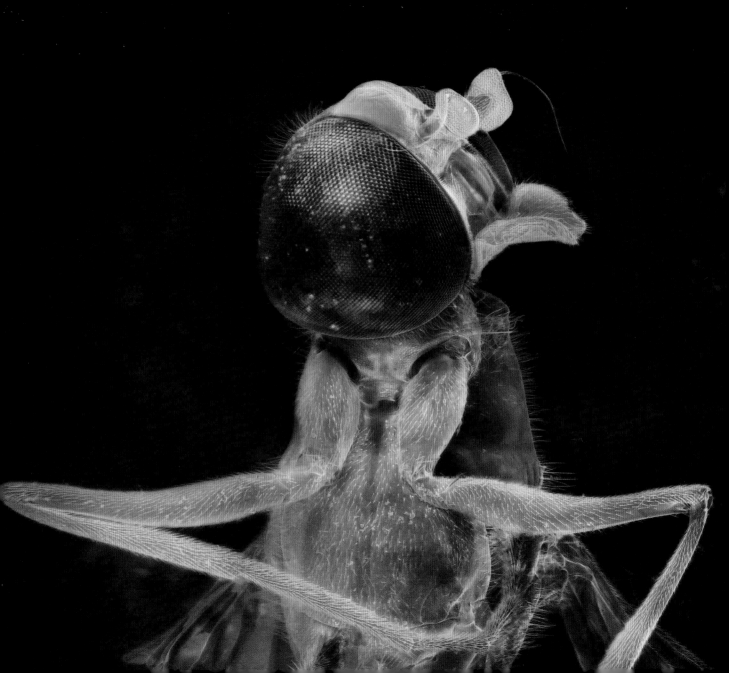

Long-Legged Fly

These flying metallic-like jewels are miniature predators that will eat nearly anything smaller than they are. They chew up their prey into a sticky ball and then suck the mass until all the juices are gone. Males can often be seen on sunlit leaves waggling their long legs to get attention from the ladies. The better-looking his legs, the more likely he'll lure a female to mate, passing on his "good leg" genes.

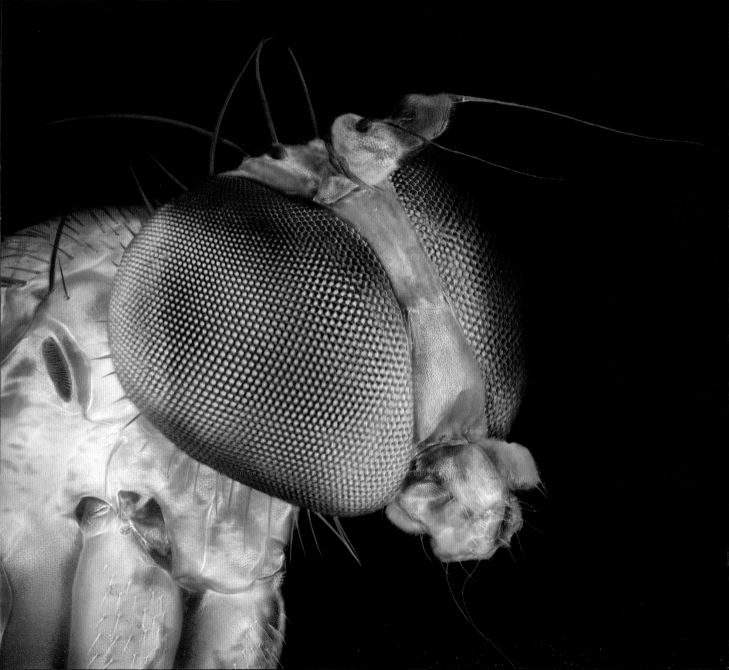

Tachinid Fly
These are parasitic flies that will attack a wide variety of prey. Bristle-covered females will glue an egg to an unsuspecting host, the most common of which is a caterpillar. The glue is so strong that removing the egg will rip a hole in the host. When the egg hatches, the miniature maggot burrows in, eating the caterpillar from inside out until the maggot erupts to pupate, leaving the dead husk of the caterpillar behind.

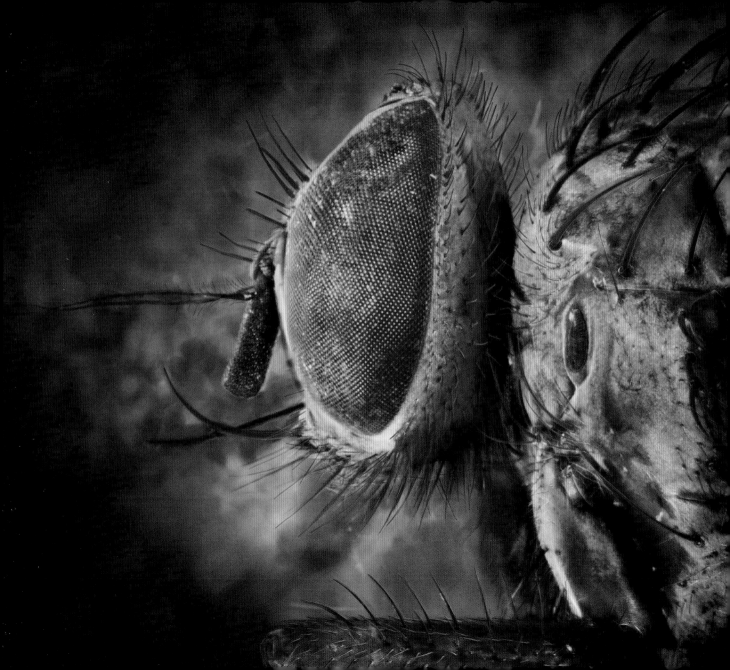

Hoverfly

To avoid being eaten by predators, these flies mimic wasps or bees with their bright markings. They are one of the few insects that can hover and even fly backward, a tricky skill males use to attract females. Females can be choosy when it comes to mates and where they lay their eggs; they carefully smell for plants that are being eaten by aphids. The stronger the smell, the more eggs they will lay. Once hatched, their larvae will hunt and devour aphids by the hundreds.

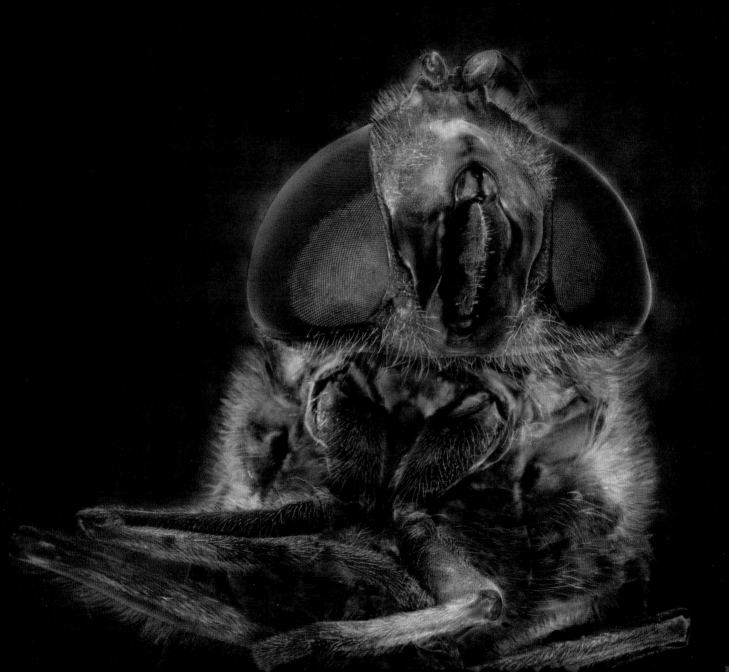

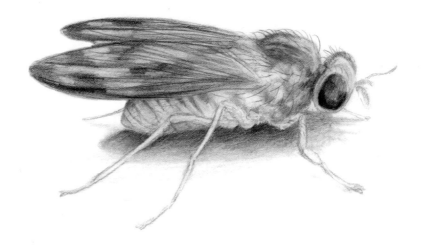

Lauxaniid Fly
This family of flies can be found almost anywhere around the world. Generally less than 7 mm in length, what they lack in size they make up for in abundance. The larvae of these flies make them one of the most important insects in tropical regions, as they eat decaying plant matter and recycle the nutrients to feed the lush vegetation. Most are generalists, eating a wide variety of decaying items, but some are extreme specialists; for example, the larvae of one species only eat decaying plant matter in bird nests.

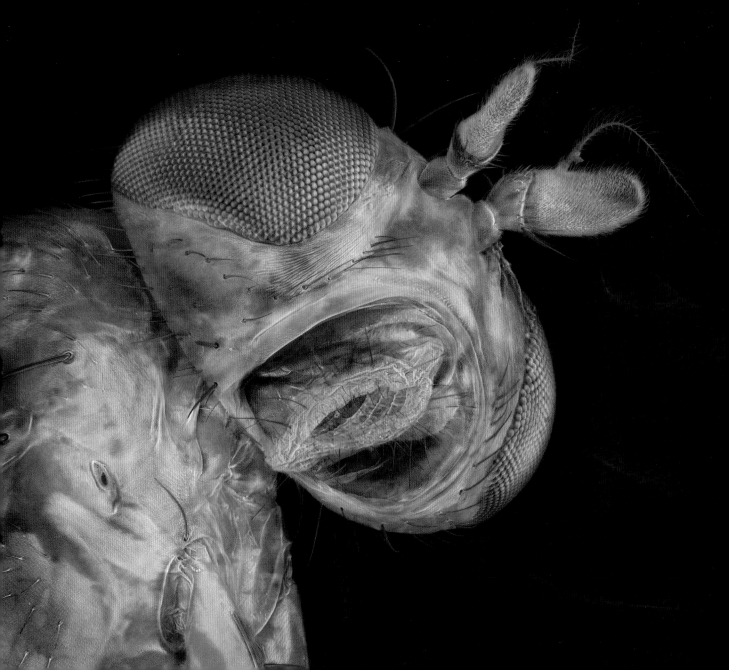

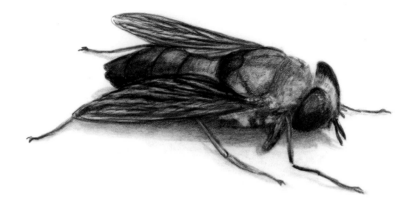

Horsefly

Horseflies have tortured humans for millennia. The ancient Greeks wrote the maddening persistence of these biting flies into their mythology. Females cut into a victim's skin with scissor-like mouthparts and then lap up the blood; they keep the blood flowing by spitting anticoagulants into the wound. Once a wound is open, other Horseflies will come to the same spot to dine.

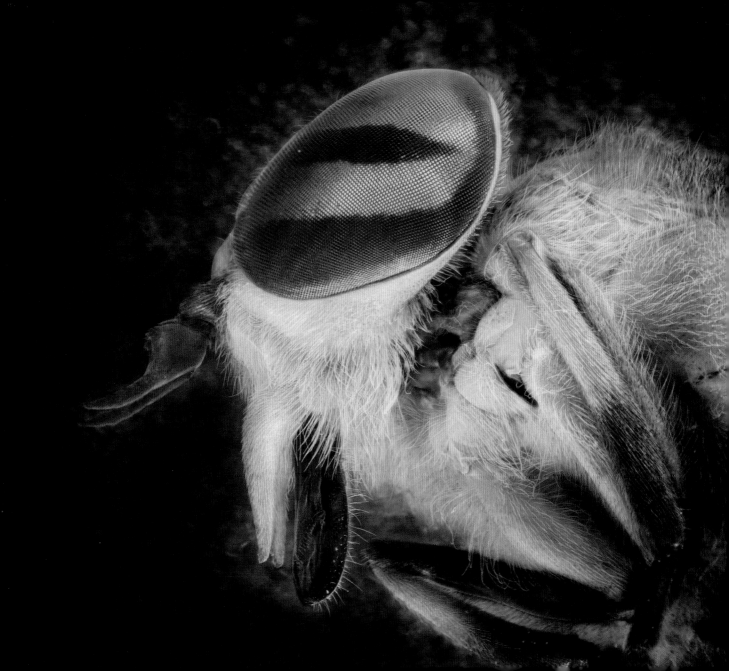

Deerfly

When you are walking in the woods nearly anywhere in the world, during a warm summer morning these are the flies that are likely to spoil your time. Deerflies use their beautiful multifaceted eyes to detect movement and hone in on victims. Like Horseflies, the female Deerfly is persistent in trying to draw blood from victims so as to have provisions for her eggs. The predatory larvae develop in wet areas and are equipped with fangs and venom to immobilize and digest other insects that come across their path.

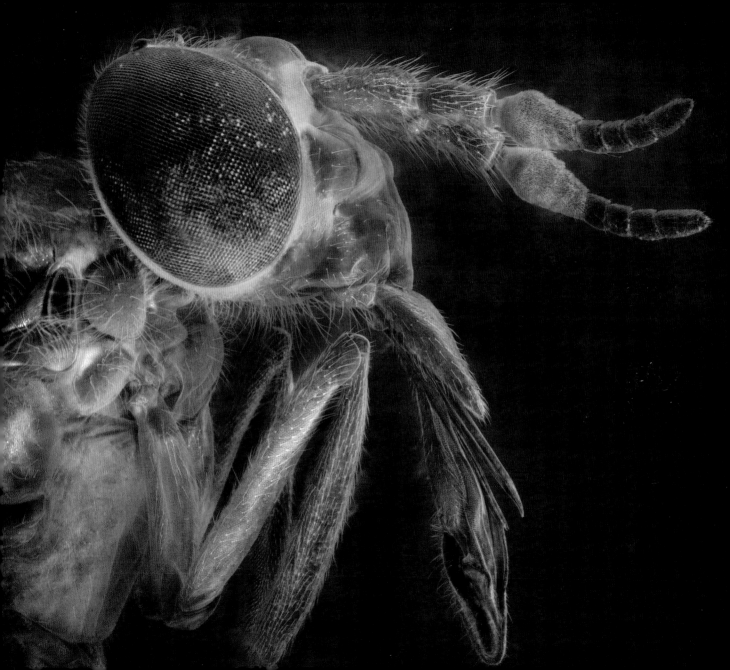

Crane Fly

These large flies are often mistaken for giant mosquitos and are sometimes referred to as "Mosquito Hawks." They are in fact harmless; the adult stage of this insect often does not eat anything and is short-lived. Crane Flies' long legs easily break off in the mouths of predators, allowing them to escape. The larvae, often called "leatherjackets," usually grow up in wet soils, eating decaying vegetation.

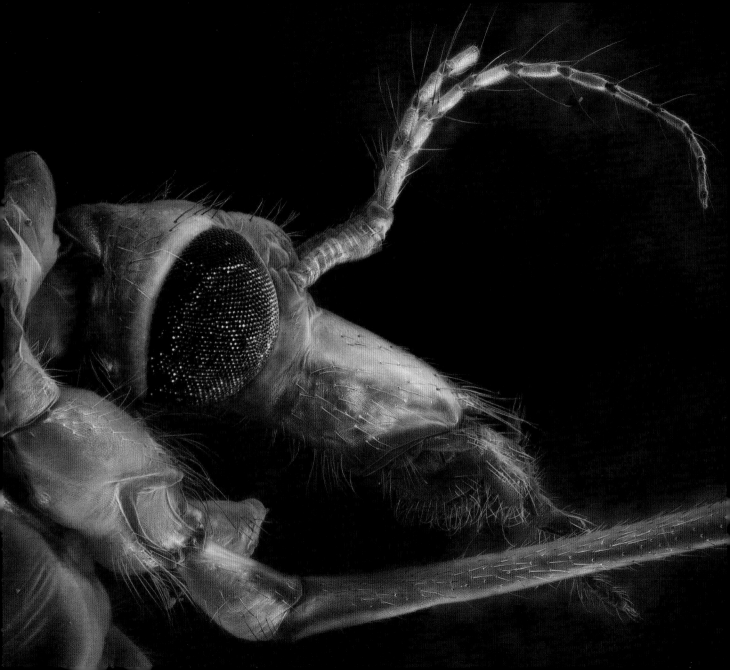

Aedes Mosquito

This is the deadliest animal on the planet, killing an estimated 725,000 people each year by infecting them with a wide variety of diseases. Using a modified mouth shaped like a hypodermic needle, females pierce flesh and inject anticoagulants and anti–immune response chemicals before they suck up blood. Some people have allergic reactions to their saliva and will develop itchy rashes at the site of injection.

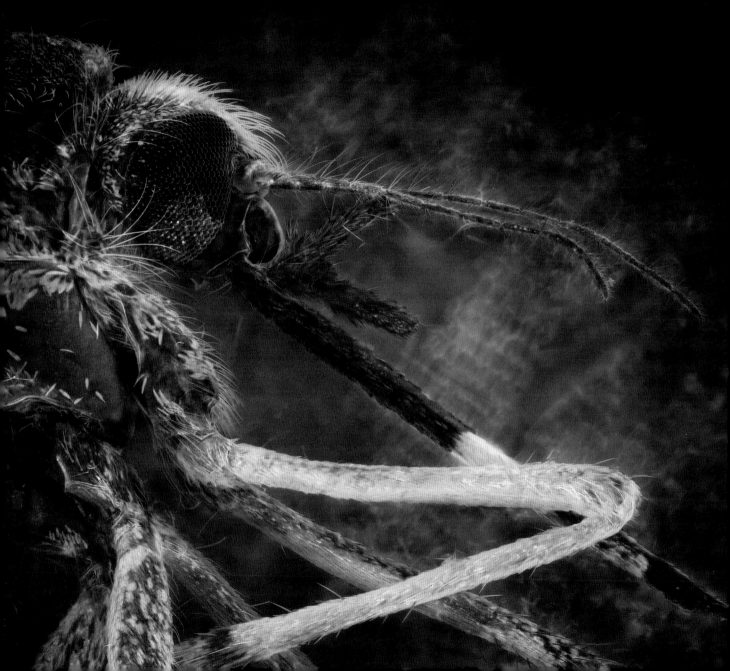

LEPIDOPTERA, ODONATA, AND NEUROPTERA

MOTHS, LACEWINGS, DRAGONFLIES, AND DAMSELFLIES

The Flyers

These insects are distinguished by their prominent wings.
Moths and Lacewings dominate the night air; Dragonflies and Damselflies
rule the day. We don't as often run into their larval forms;
the caterpillars keep to themselves, discreetly chewing leaves, and
nymphs (immature adults) hunt fish and insects underwater.

Forage Looper Moth

Moths (Lepidoptera) outnumber butterflies—their flashier daytime cousins—nine to one. Few have gained the attention of scientists, with only a fraction of the 160,000 estimated species described. Most are small, nondescript, and hard to find. It is very likely that you have a species unknown to science in your backyard. The caterpillars can be found munching away in the clover of your lawn, and adults will come to your lights at night.

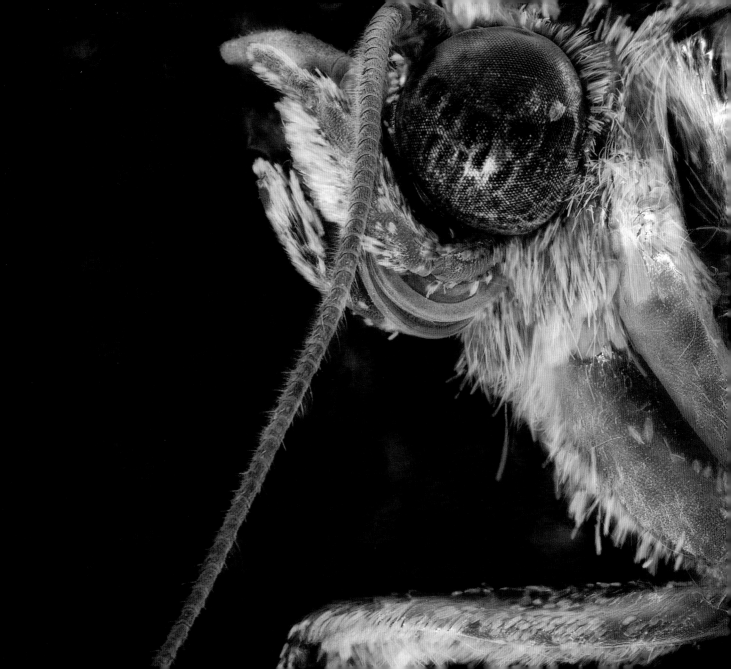

Grape Skeletonizer Moth
This small, peculiar moth (Lepidoptera) lays its eggs on the underside of grape leaves. When the larvae hatch, they line up and proceed to eat all but the larger veins of the leaf, leaving a skeleton. All the while, the larvae sport black tufts of toxic spines that inflict pain on any unsuspecting person.

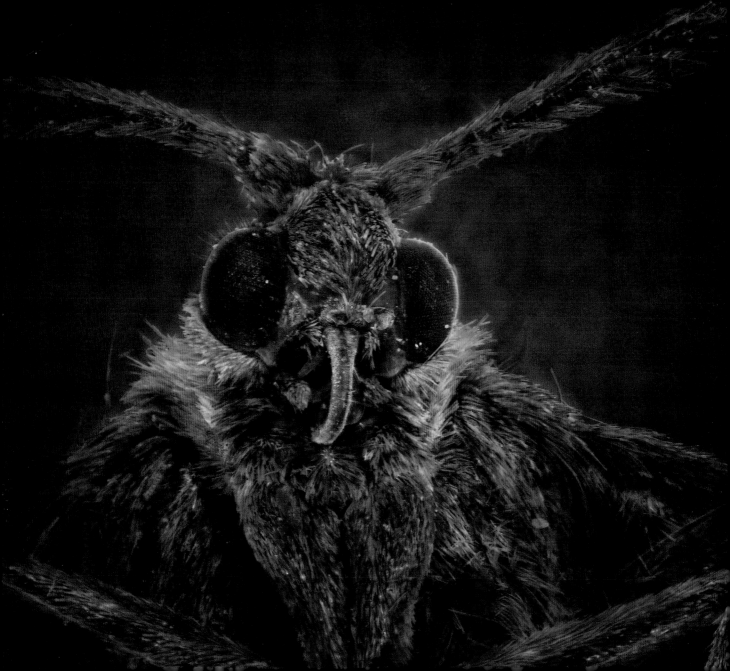

Ailanthus Webworm Moth
Named after its food, this moth (Lepidoptera) looks more like a flower beetle or a wasp with its striking colors that warn of its toxicity. The female moth will often lay her eggs in an old empty cocoon, and the larvae will spin a web around their food for protection while they dine. Their primary food is the "Tree of Heaven" (Ailanthus), an invasive plant imported from Asia that is a threat to North American ecosystems.

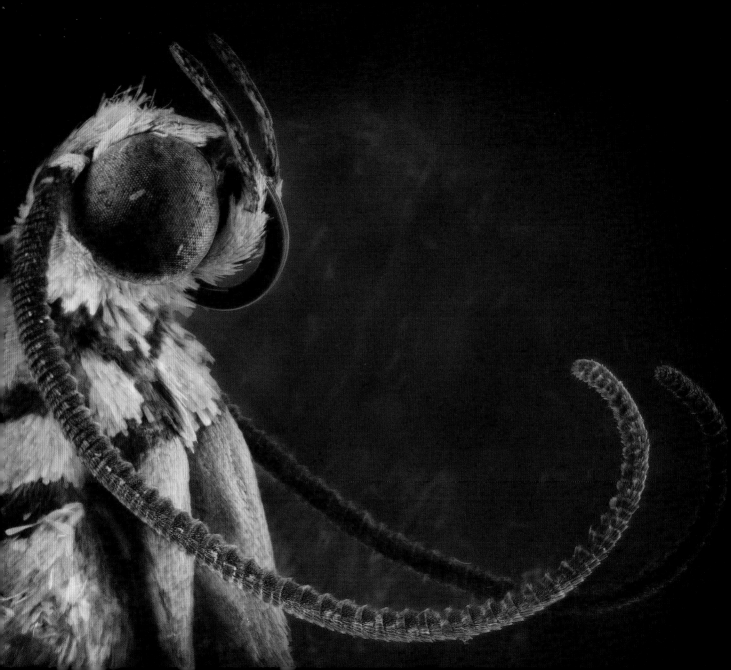

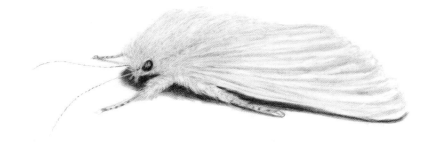

Owlet Moth

These moths (Lepidoptera) are part of the large Noctuidae family, which accounts for nearly 25 percent of all moths and butterflies. Named for the fact that all are nocturnal, members of this family have evolved the ability to detect the sonar calls of bats to avoid being eaten. When they hear a bat, they stop flying and drop from the sky. Some have developed a sinister side, with a strong mouthlike appendage (called a proboscis) that they use for drinking blood.

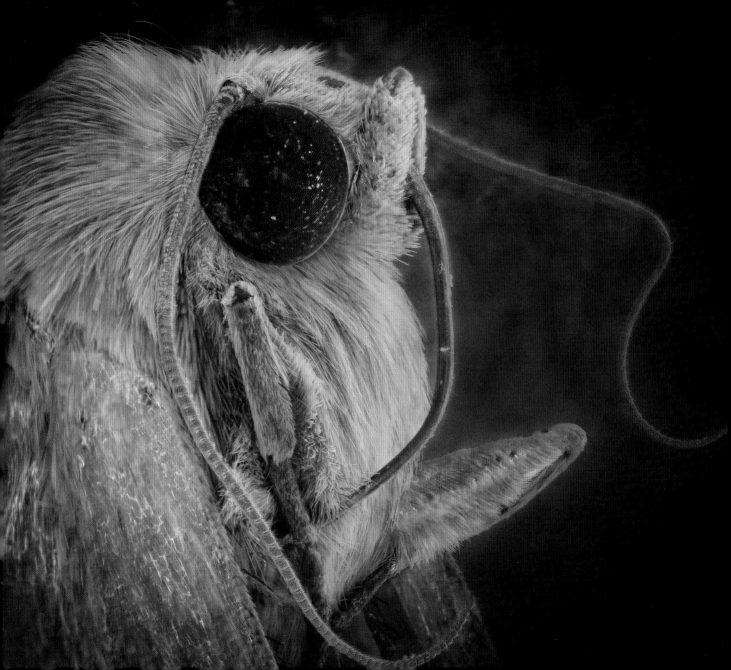

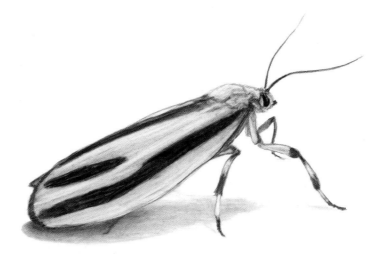

Scarlet-Winged Lichen Moth
These moths
(Lepidoptera) are toxic. They collect the poisons from the lichen they eat off the trees they
live on. The caterpillars will eject their poop up to thirty body lengths away, a move likely
to keep predators and parasites from detecting their smell. Adults flying at night will emit
a noise to warn bats that eating them is a bad idea.

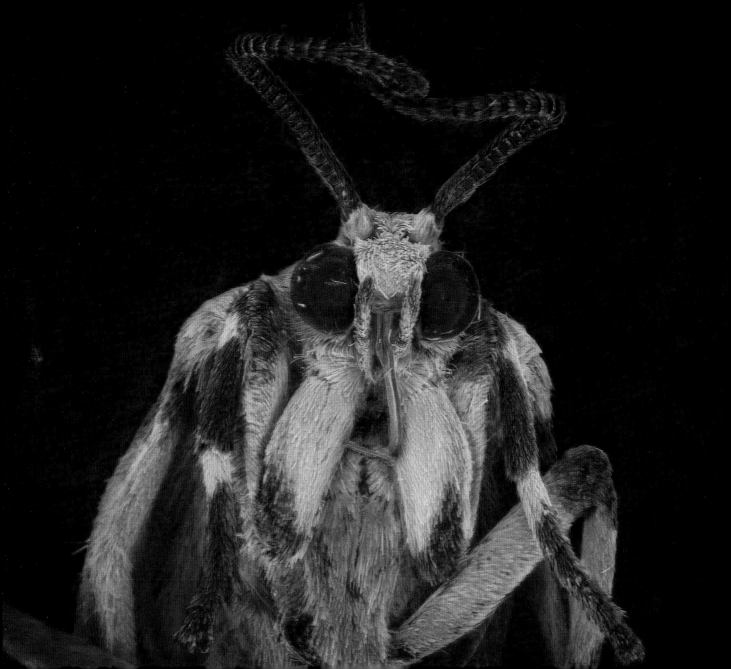

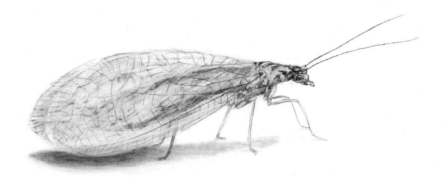

Green Lacewing

This is a delicate monster. The larvae are called "aphid lions" because they roam plants looking for victims. A larva will eat as many as two hundred aphids per week. Once it grows big enough, it will retreat into a cocoon for a couple of weeks and then emerge as a ravenous adult that will help protect plants from aphid attack.

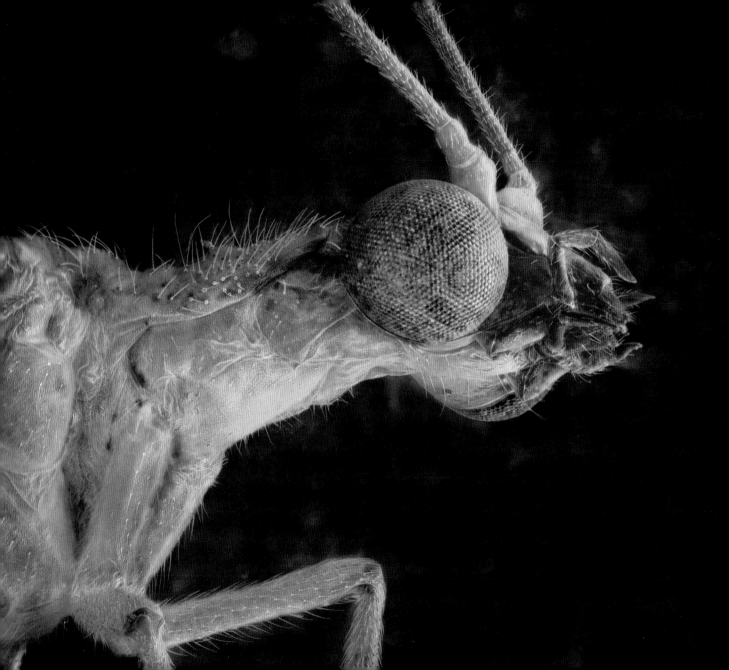

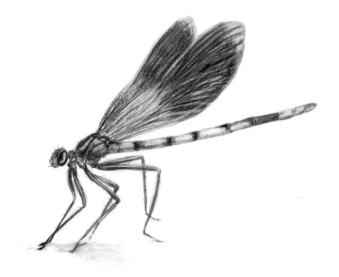

Damselfly

These insects (Odonata) are similar to Dragonflies and are only found near water. Most of their lives is spent as aquatic nymphs that eat other insects like mosquito larvae and water fleas. When ready, the nymph climbs out of the water onto a dry stem. Once dry, the skin of the nymph will split, and the adult will emerge. The flying adult will use long hair-covered legs to grab other insects off leaves and stems. Some species of Damselflies specialize in plucking spiders from their webs.

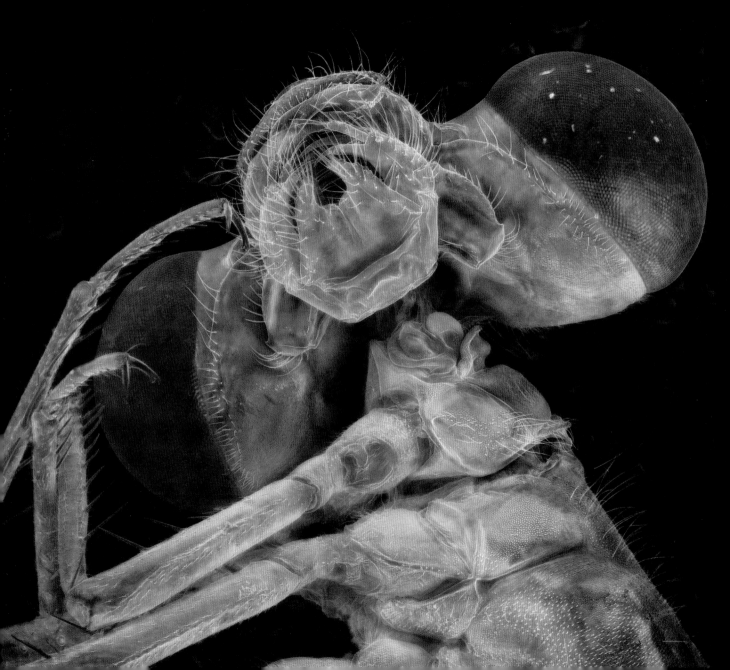

Dragonfly

These insects (Odonata) are fearsome aerial and aquatic predators. As aquatic nymphs they will eat prey as large as tadpoles and small fish; they can move at high speeds by shooting water out of their anus, and they rapidly extend a hinged mouth to grab victims. Nothing matches adult Dragonflies in agility; using exceptional vision and flying skills, they have been shown to use "motion camouflage," adjusting their heading and speed so that they appear motionless as they approach their prey. A single dragonfly can eat hundreds of mosquitos and other flying insects each day.

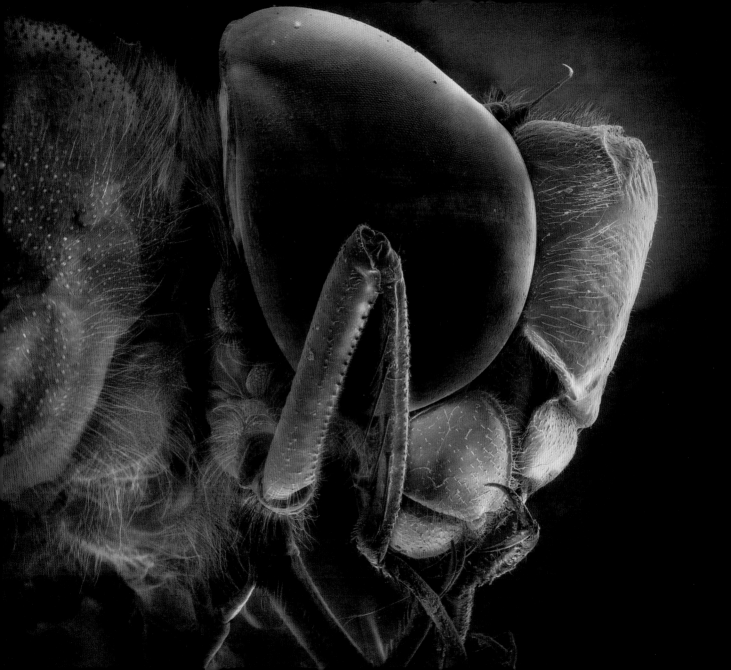

HEMIPTERA

The Suckers

These insects can't chew. With their strawlike mouths,
they instead pierce their food to suck out the juices. Though it
varies across species, most in this order are able to feed on a variety
of liquids, such as the sap of trees and human blood.

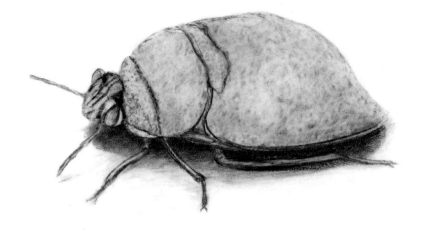

Kudzu Bug

An invading horde introduced from Asia in 2009, this globular stink bug has spread across the southeastern United States, sucking juice from plants and congregating in masses. When it gets cooler, the Kudzu Bugs congregate at white surfaces around your house. Touch them and they release noxious compounds that can leave a rash.

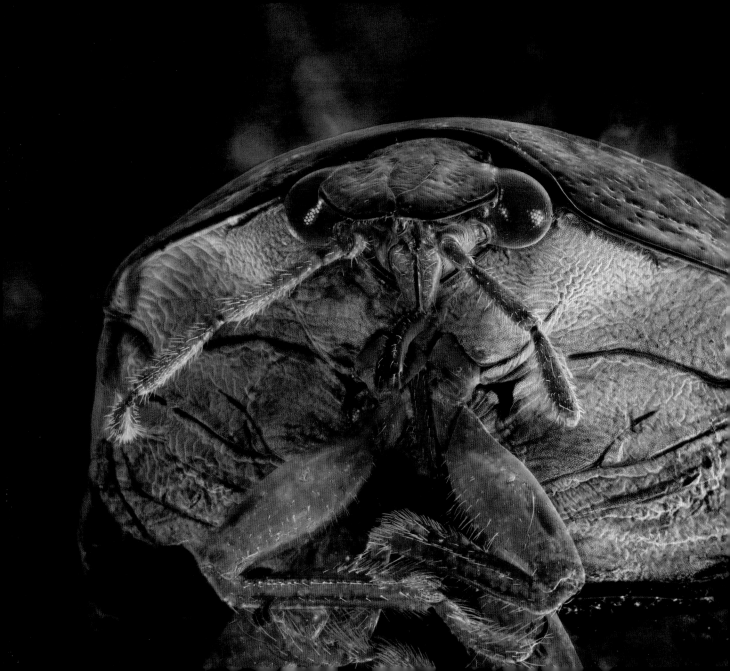

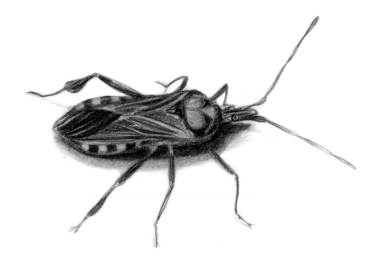

Seed Bug (PLANT BUG)

The Seed Bug is considered one of the worst offenders in the lineup of insects that are bad for farmers. They will eat nearly anything that we choose to grow for food, using their small needle-like mouthparts to stab and suck out the juices from the most tender parts of a growing plant. Flower buds, young fruit, and new leaves will wither and fall due to a seed bug's spreading of plant viruses.

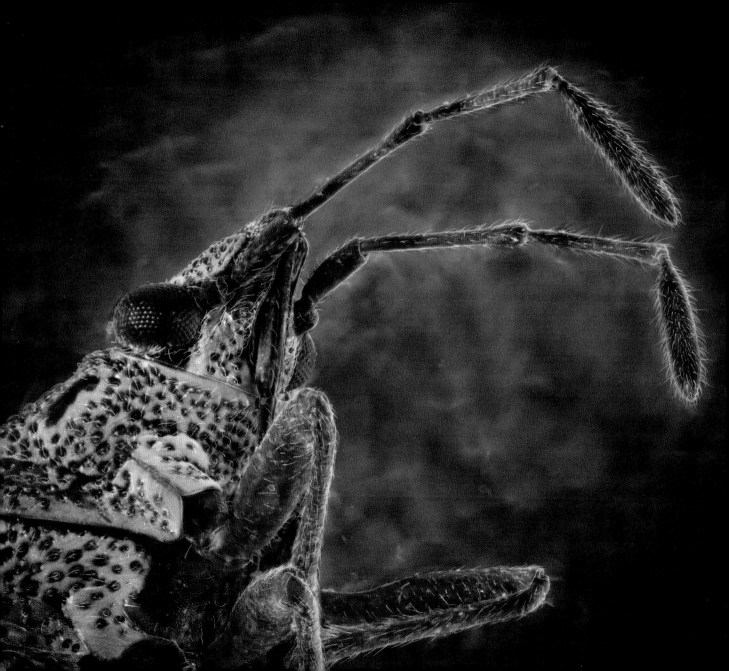

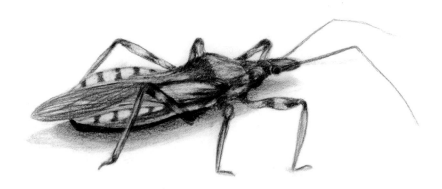

Assassin Bug
These ambush predators display elaborate camouflage and are considered helpful by farmers because they eat plant pests. When a victim gets close enough, the Assassin Bug will quickly inject it with a lethal cocktail of poison and digestive enzymes; the victim is then predigested and sucked dry by a long strawlike mouth. Also known as "kissing bugs," some members of this family suck blood from near the mouth and eyes of unsuspecting humans while they sleep.

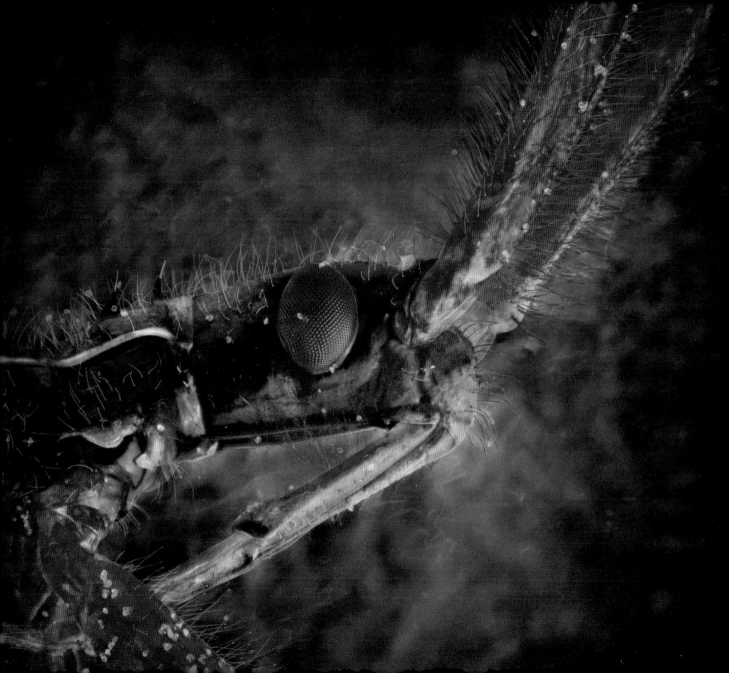

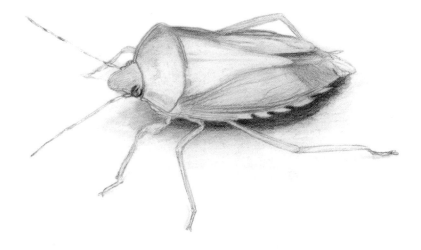

Green Stink Bug

Green Stink Bugs are serious agricultural pests. They ingest sugars and other nutrients from a wide variety of fruits and vegetables, stunting the growth of the affected area and leaving it vulnerable to infection by plant viruses. The wounds left on fruit are ugly and unpalatable for the modern consumer.

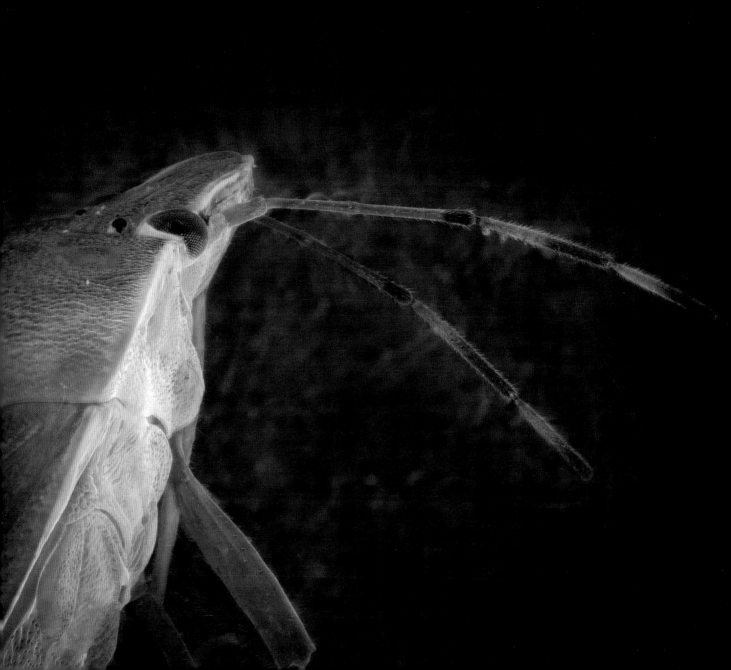

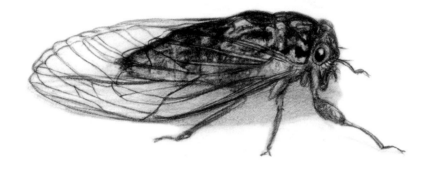

Cicada

These large, loud insects of summer spend most of their lives underground as nymphs, sucking juices from tree roots. Some will stay underground for seventeen years before emerging in their millions. Adult males are essentially just large sound boxes; their bodies are mostly hollow, using the internal cavity to produce a loud call for females. Microscopic examinations of adult wings reveal waxy cones and small nanospikes, which keep the surface waterproof and self-cleaning. The spikes will impale and kill any bacteria that happen to land on them.

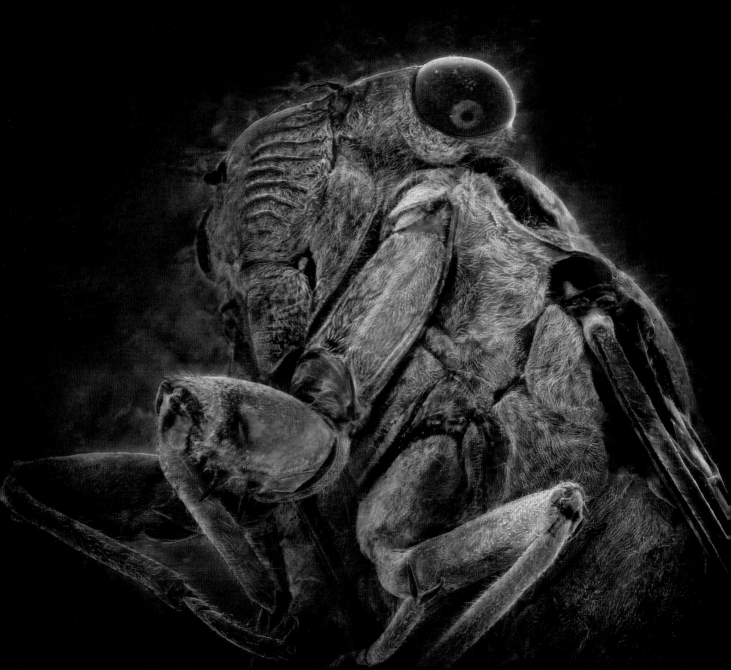

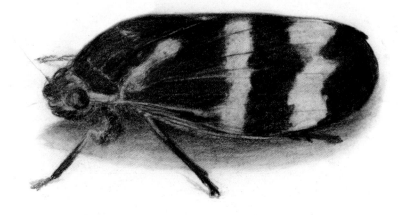

Froghopper

The nymphs of these insects can be found on plant stalks covered in "spit." They exude this bad-tasting mass of bubbles to protect themselves from predators and keep from drying out. Projecting their spit for more than one hundred body lengths, and experiencing forces of over five hundred times that of gravity, as adults they can outjump even fleas. (Specially equipped and trained fighter pilots can experience a maximum of nine times gravity before passing out.)

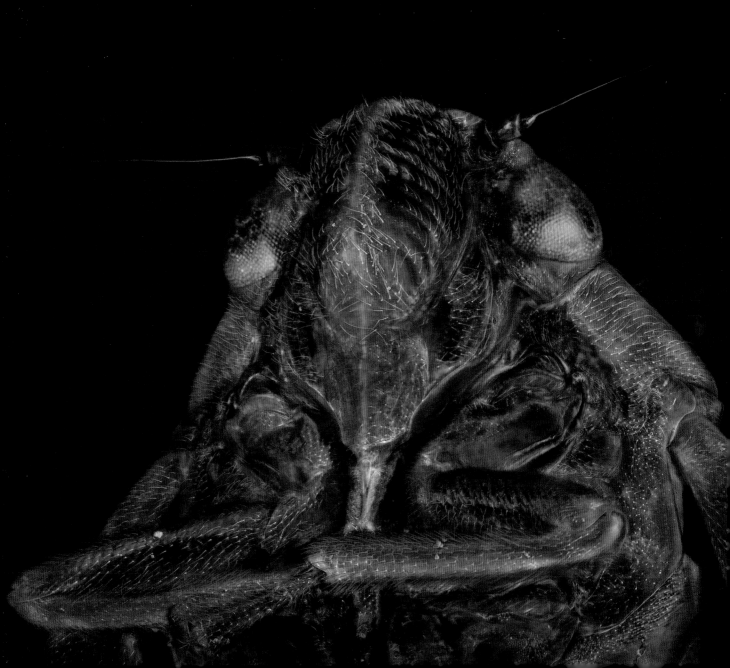

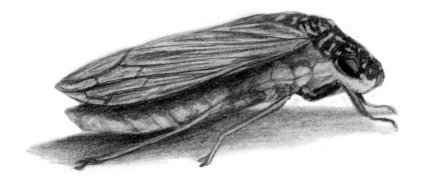

Proconiine Leafhopper

These bugs are also called Sharpshooters. Excellent jumpers, they will move from plant to plant sucking fluid through their sharp mouths. As plant fluid is mostly water, they need to pump and filter a large volume to get the nutrients they need, ejecting any excess from their hind ends. If you have ever thought it was raining on a clear day, you may have been one of their unwitting victims. Try to sneak up on them and they will simply move to the other side of the plant stem.

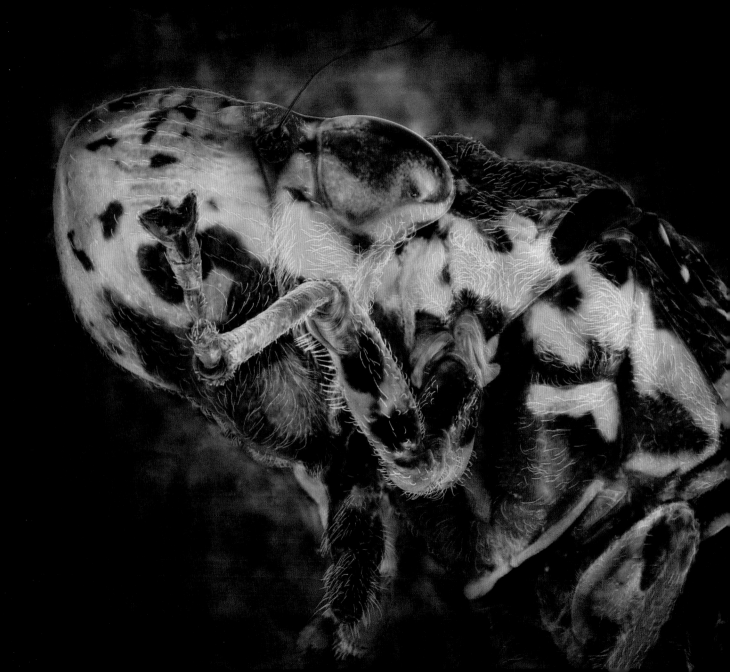

HYMENOPTERA

The Stingers

The stinger is a critical weapon for these predatory insects, because their complex chemical venoms allow them to incapacitate a wide variety of other arthropods. Nearly all members of this order can fly, with the exception of ants that only fly to mate and then lose their wings.

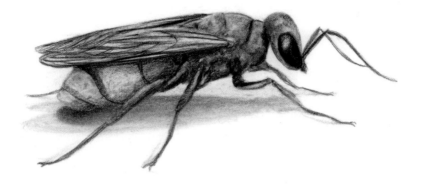

Cuckoo Wasp
Also known as the emerald wasp, the Cuckoo's dazzling color is the result of millions of microprisms embedded in its multilayered exoskeleton that refract and reflect light—making the Cuckoo Wasp look like flying jewels. Cuckoo Wasps are parasitic, laying their eggs in other wasps' nests. If they are caught in the act, they defend themselves by rolling up into a tight ball, protected by their super-tough outer layer, which is impervious to bites and stings.

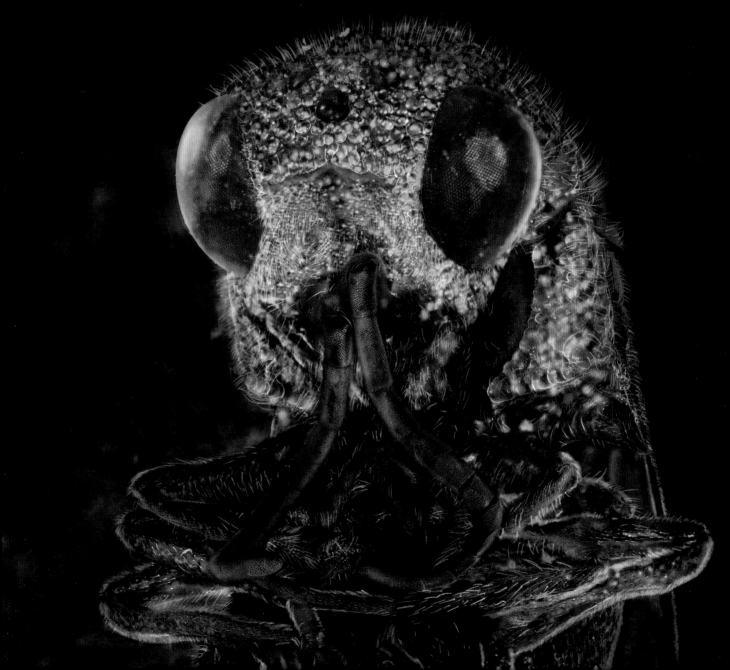

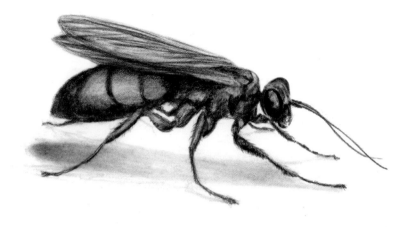

Spider Wasp

As solitary hunters, these wasps seek out spiders and paralyze them with specialized venom. The hapless spider is then dragged into a chamber, where the wasp deposits a single egg. The wasp covers the entrance with dead ants that release chemicals to deter predators. Entombed, the egg hatches and the larva slowly eats the still-living spider. The larva pupates and emerges as an adult, ready to terrorize more spiders.

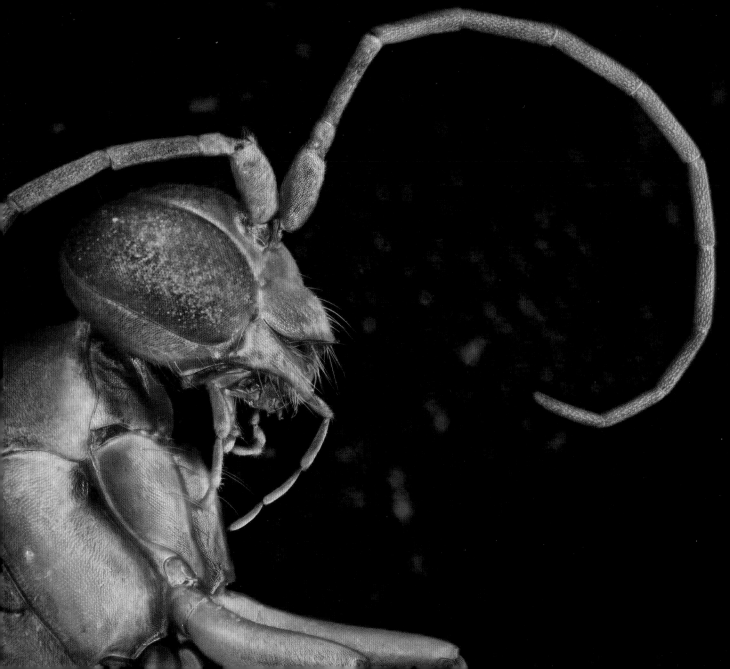

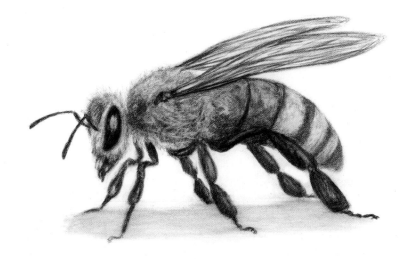

Honey Bee

These colonial wasps collect and store honey in such quantities that we can enjoy some with our breakfast. They live in hives that are made up mostly of females with a couple of freeloading drones (males) that get kicked out to mate with new queens. When a Honey Bee stings, its abdomen is ripped open to leave a pumping venom sac attached to its victim. The bee dies soon after.

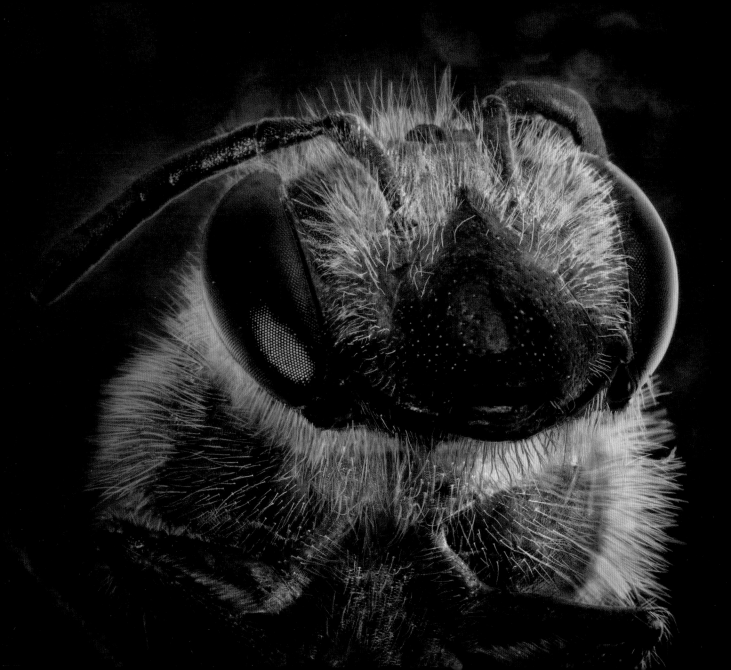

Valley Carpenter Bee

This is one of the largest bees in North America. It is a gentle giant more interested in finding pollen and nectar than bothering humans. With distinctive gold-colored males and black females, this family of bees can use their large flight muscles to regulate their body temperature, allowing them to live in more places than other bees. They can be seen on early mornings buzzing in place, getting warmed up for a day on the wing.

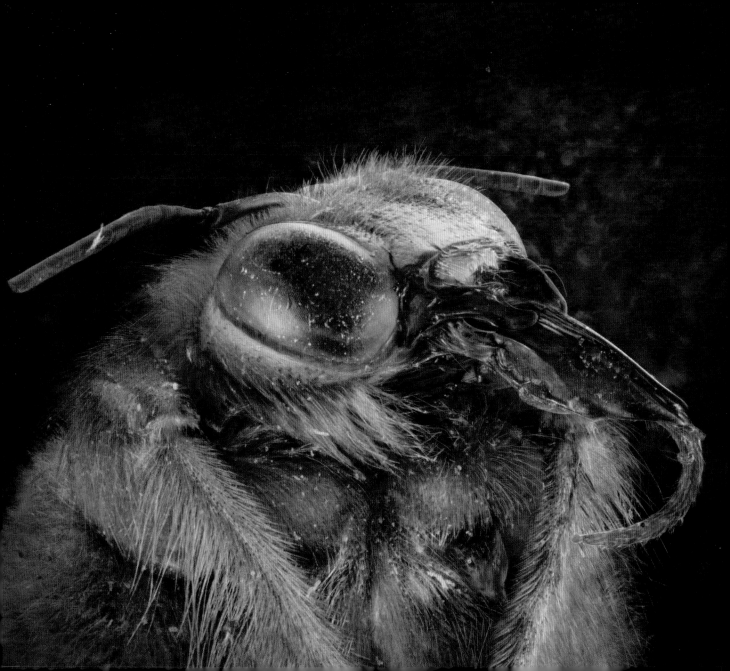

Carpenter Bee

These bees will chew perfectly circular holes in untreated wood to make their nests. They will provision these nests with "bee bread," a mixture of nectar and pollen for their developing young. Exceptional pollinators, the carpenter bee's buzz has a frequency that can shake pollen loose from flowers. Flowers that don't cooperate—ones that are so deep that the bees can't reach the pollen—are vandalized by the carpenter bees, as they will move around to the base of the flower and use their strong jaws to cut a slit and steal nectar.

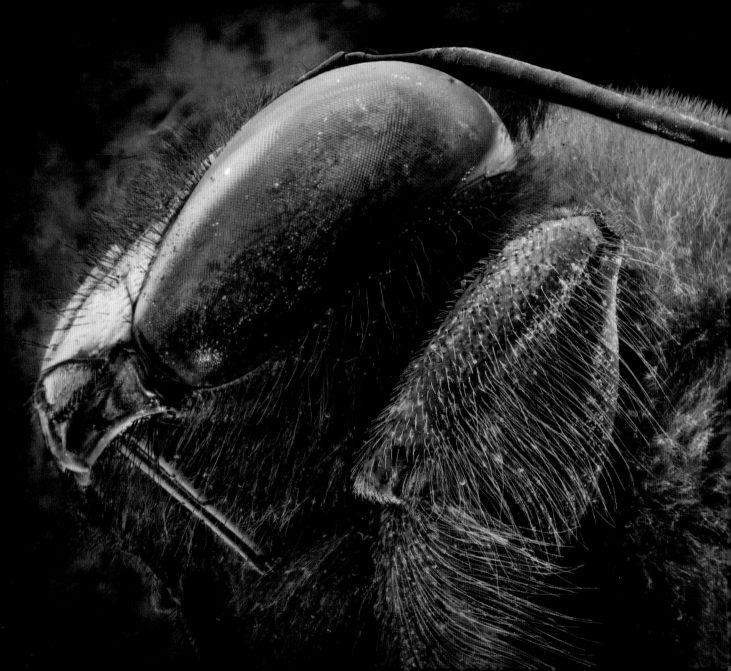

Cow Killer

Also known as Velvet Ants, Cow Killers are wingless wasps that have one of the most painful stings in the world. Their exoskeleton is rounded and incredibly strong, which helps protect these sneaky solitary insects from stings as they invade the nests of ground wasps and lay their eggs. The larvae hatch and eat the hosts, leaving empty husks of parasitized prey.

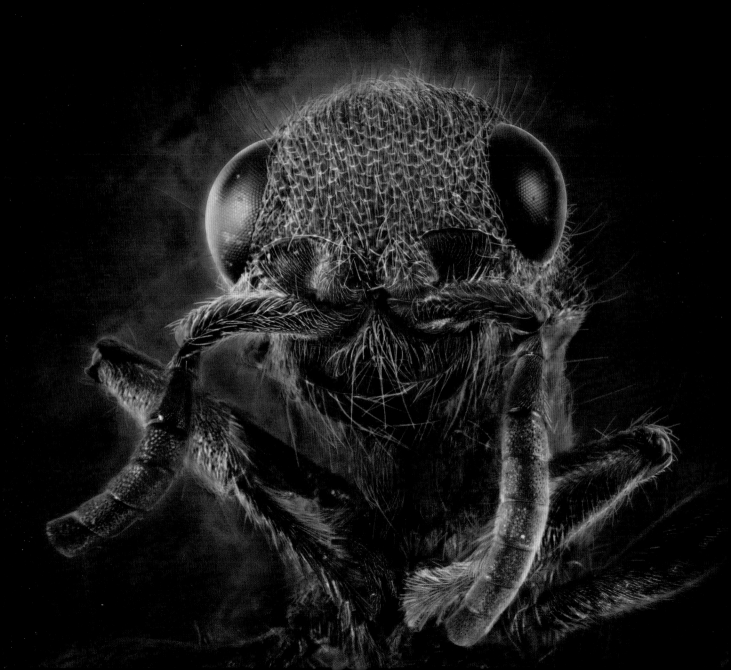

Ant
Ants are everywhere. It is estimated that there are as many as 22,000 species on earth, and that they account for 15–25 percent of the animal biomass on the planet. That solitary insect roaming your floor can lift twenty times its weight and lay down an invisible chemical trail for its sisters to follow. Its colony can solve complex problems, live for decades, and stealthily clean your house of crumbs and critters.

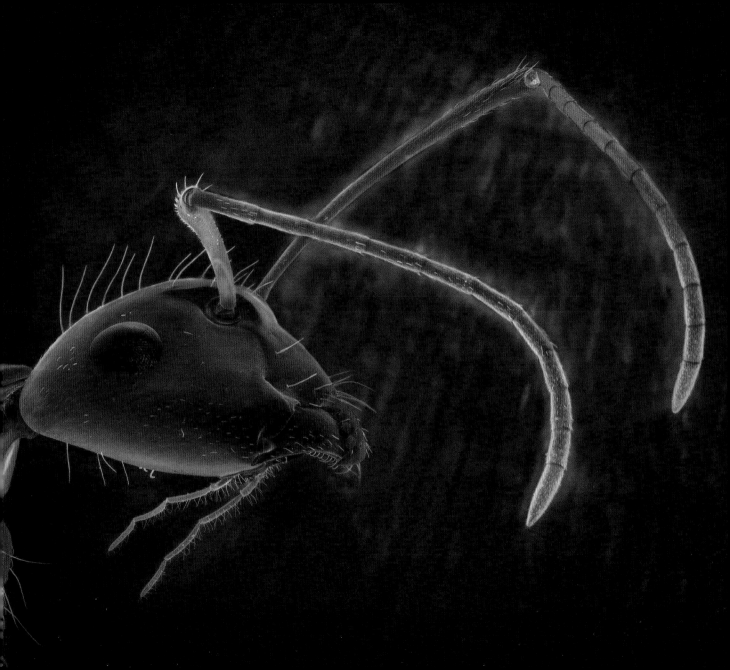

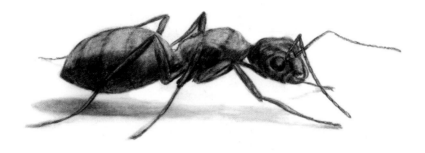

Carpenter Ant

These large ants are called carpenters because they have chisels for mandibles. Deep inside your window sill or the dead trees in the forest, they carve out passages and galleries to protect their colony, leaving small piles of fine sawdust at the openings of their nests. Their jaws can be used to fiercely defend themselves, easily cutting into flesh. If that does not work, some species of Carpenter Ant can explode and release a toxic goo all over their enemies to protect the colony.

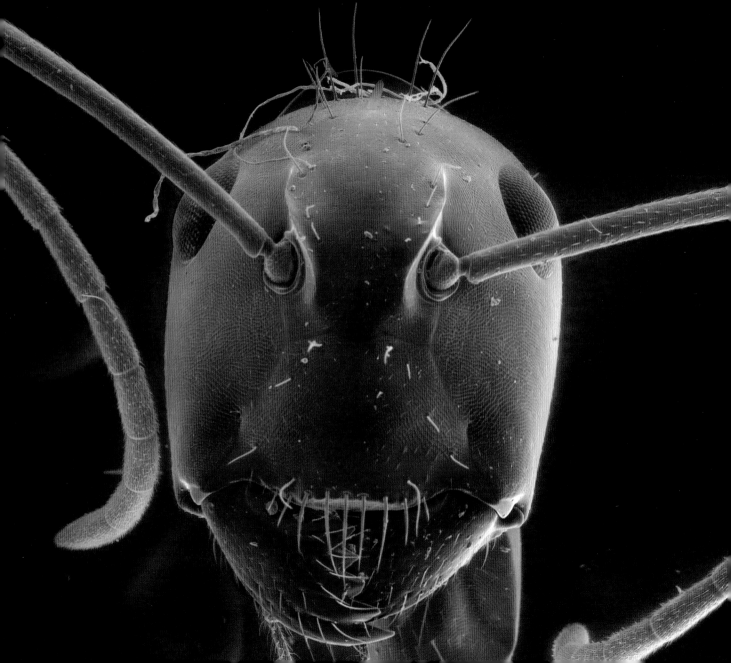

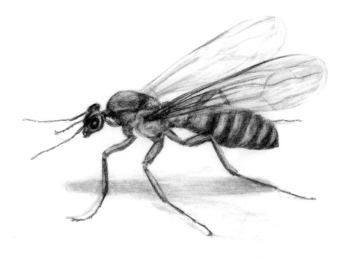

Winged Ant

Imagine that just a handful of people in your neighborhood were born with wings every few years. In ant colonies this really happens. A few select males and females develop wings just like their distant relatives, the wasps. They are tended and cared for by all the wingless sisters in the colony. When the time is right for the colonies in the area, all of the winged females and males are evicted from the nest to soar high and mate. Each impregnated female will become queen of a new colony while the male will die within days. Underground she will lose her wings and lay eggs for the rest of her life.

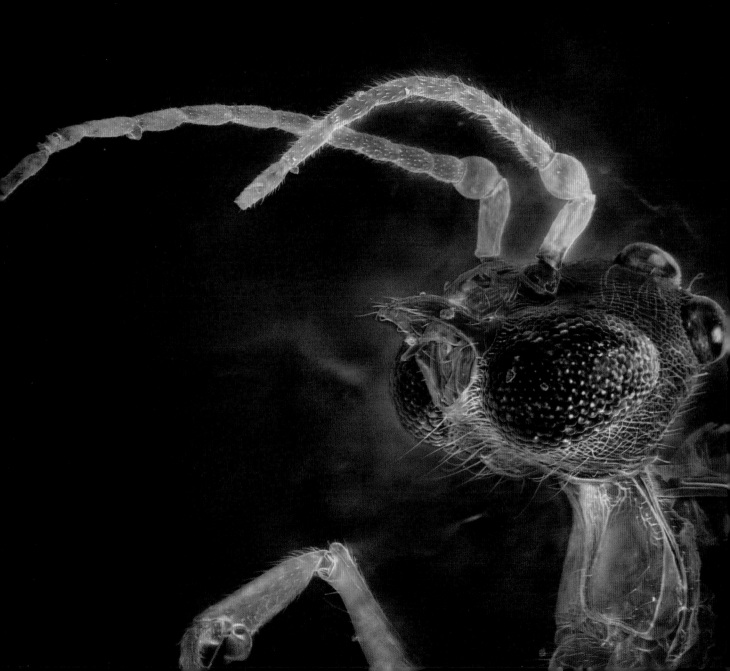

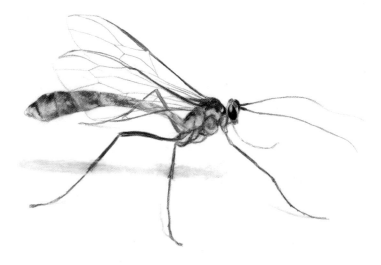

Ophionine Wasp

This parasitic wasp is a member of the enormous Ichneumon family—a group that includes more than 100,000 different species. Ophionines hunt and lay eggs on specific prey such as beetle larvae. The newly hatched wasp larva is not in a hurry to eat the innards of its victim. It will delay its development to make sure the host is fully grown before it eats it from the inside out. It can be patient thanks to its mother wasp, which infects the host with a virus so that her larva can avoid detection.

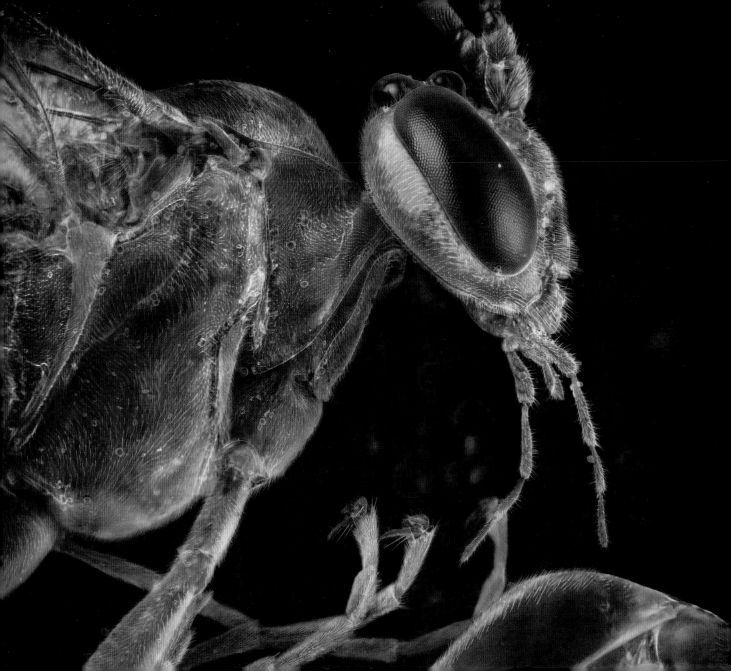

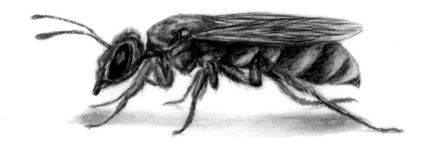

Sweat Bee
These wasps are named for their habit of buzzing around and drinking your sweat. They can be cleptoparasitic, meaning the females will invade the nest of another bee species and eat and replace one of the host eggs with her own. The hosts will unknowingly defend and raise the sweat bee larva until it emerges to perform its own act of deception on another nest. If disturbed, the Sweat Bee will lightly sting.

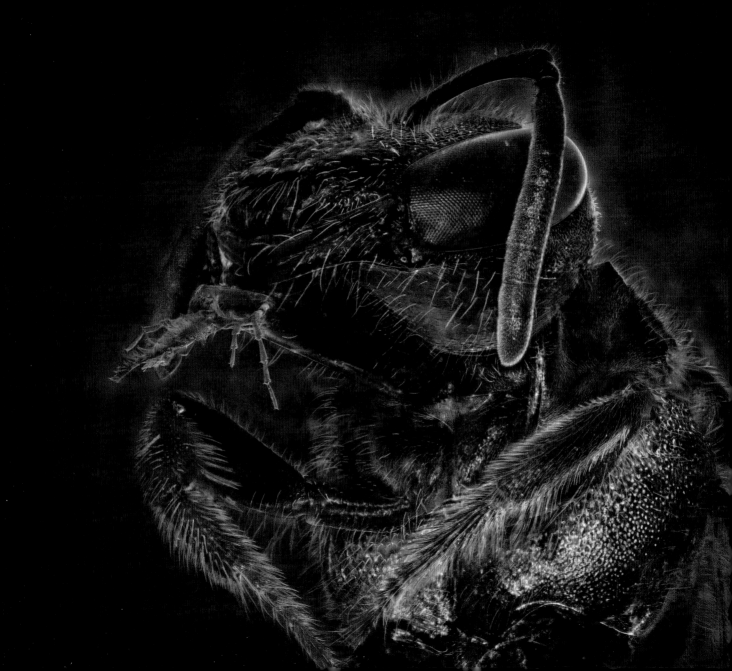

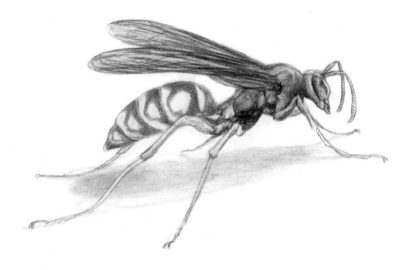

Gold Paper Wasp

Members of the Polistinae family, Gold Paper Wasps create paperlike nests using chewed-up wood fiber. A colony is often founded by multiple females that have survived the winter. They establish dominance by eating each other's eggs until one female emerges as the most aggressive. She becomes the mother for all the new wasps in the colony, but her rule will last for only a year. Toward the end of the season workers will cannibalize some of the young to feed the strongest remaining grubs.

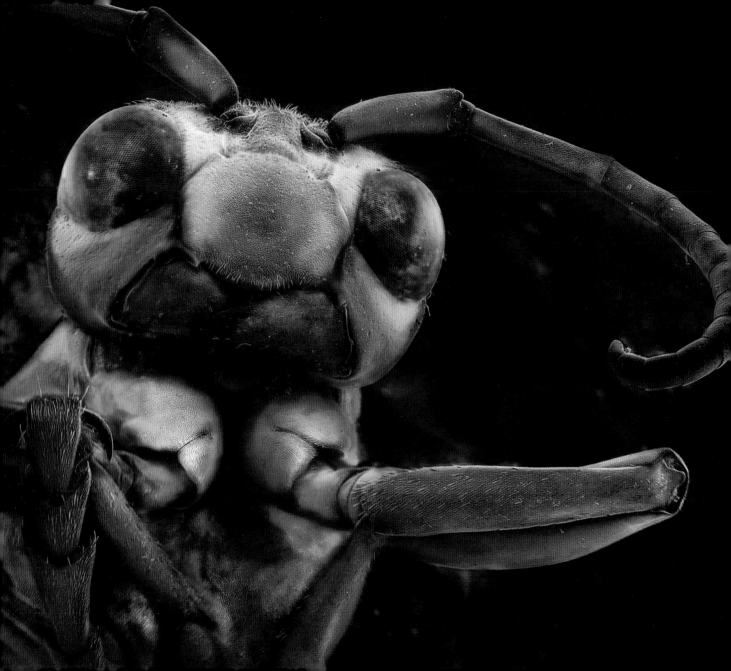

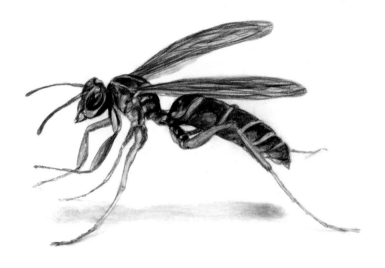

Black Brown Paper Wasp
These wasps have distinctive faces and can recognize each other. As wood foragers, they use a slurry of saliva and masticated wood pulp to build their chambered paper nests. Hanging from trees or houses, a mature full-size nest can consume up to seven pounds of insects per day. As food runs out late in the season, they will search out the local picnic for meat.

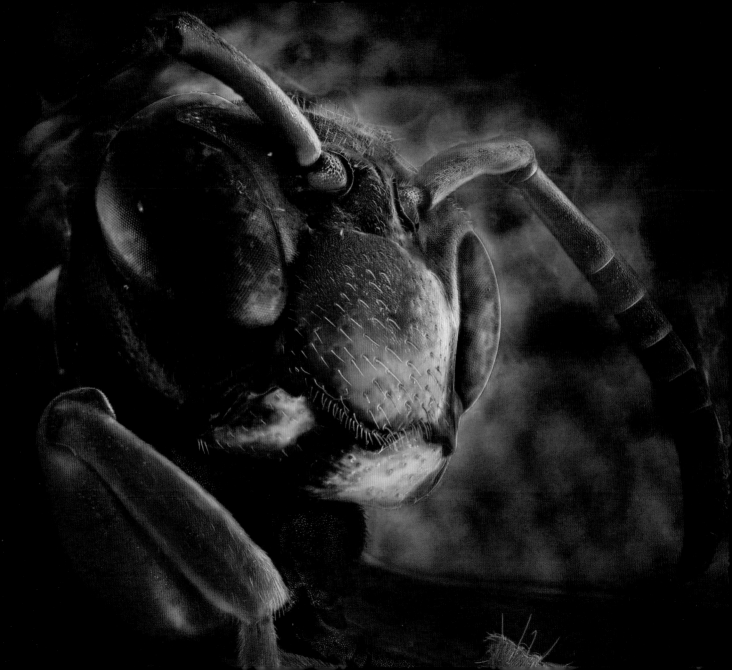

NOTES ON PROCESS

When considering a fine art photograph, many people have a mental image of a single-lens reflex "old-timey" film camera, or more often, a studio filled with flashing strobes. In contrast, my process dips a bit into the sciences, as I use a combination of up to three different microscopes in order to complete my portraits of insects and other arthropods.

First, I scout out my tiny subjects during my daily routines, in my yard, in my home, or on my way to the office. Once collected, I freeze them to preserve their fragile bodies. (This often causes confusion when unsuspecting houseguests reach into my freezer for some ice.) After I've gathered a number of candidates for photographs, I usually schedule time at my university's imaging lab.

The images start as color digital files from a *Stereoscope Light Microscope*. I carefully arrange bugs under LED lighting, small reflectors, and diffusers in order to achieve a "classical portrait"–like effect. This takes a steady hand, working with tweezers, and watching my daily caffeine intake. I take several images of each creature, making sure I get the best color and lighting, in a few different poses.

Next, I image the same bug with the *Scanning Electron Microscope* (*SEM*). This microscope produces a much sharper image than the optical light microscope, because instead of light, it uses a focused electron beam to bombard a specimen in its vacuum chamber. The image is created by recording a combination of low-energy secondary electrons emitted by the specimen, and the high-energy backscatter electrons, reflected off the specimen. This process is not exactly a snapshot,

because it requires multiple color and SEM images of the same insect, taken at different focal distances. Blending these different sharp areas of the same image is called focal stacking.

Each of my final photographs may be put together from parts of ten to twenty different images, so the actual photography session takes a few hours, depending on the complexity of the creature.

In the end, I digitally composite the color images from the Stereoscope Light Microscope with the monochromatic images from the SEM to complete the portrait, combining realistic color with the detail of electron microscopic imaging. I have to be careful to match the exact position of the animal under both microscopes, so that the color image will perfectly overlap the monochromatic SEM image.

As a photographer, I celebrate the process of making art. With the naked eye, I see an unexceptional brown bug. But once I begin, I have a totally new perspective, as the microscopes reveal wonderful colors and details. Sometimes, the most unassuming creatures are turned into the most expressive portraits.

ACKNOWLEDGMENTS

I owe a great debt of gratitude to many people who aided the creation of this book over the years. First of all, to my contributors, Tim Christensen for his insightful text, and Isaac Talley for his remarkable drawings accompanying my photographs. To my colleague Angela Franks Wells, for helping with the selection of images whenever I needed it and supplying an occasional found insect. To Matt Bertone, for always responding in record time with an identification of all the creatures. To Tom Fink, for graciously allowing me to tinker around his lab and teaching me how to use the Scanning Electron Microscope. To Rob Dunn, for recognizing the intangible gridwork connecting science and the arts. To Dennis Sipiorski, my first art professor and mentor, for always being himself and teaching me the value of hard work. To my parents, Melita and Josip, for their unyielding support and courage to let go. And finally, above all, to my wife, Annette, whose love, humor, appreciation of art experiments, and tolerance of all weird things in our freezer is unsurpassed.

because it requires multiple color and SEM images of the same insect, taken at different focal distances. Blending these different sharp areas of the same image is called focal stacking.

Each of my final photographs may be put together from parts of ten to twenty different images, so the actual photography session takes a few hours, depending on the complexity of the creature.

In the end, I digitally composite the color images from the Stereoscope Light Microscope with the monochromatic images from the SEM to complete the portrait, combining realistic color with the detail of electron microscopic imaging. I have to be careful to match the exact position of the animal under both microscopes, so that the color image will perfectly overlap the monochromatic SEM image.

As a photographer, I celebrate the process of making art. With the naked eye, I see an unexceptional brown bug. But once I begin, I have a totally new perspective, as the microscopes reveal wonderful colors and details. Sometimes, the most unassuming creatures are turned into the most expressive portraits.

ACKNOWLEDGMENTS

I owe a great debt of gratitude to many people who aided the creation of this book over the years. First of all, to my contributors, Tim Christensen for his insightful text, and Isaac Talley for his remarkable drawings accompanying my photographs. To my colleague Angela Franks Wells, for helping with the selection of images whenever I needed it and supplying an occasional found insect. To Matt Bertone, for always responding in record time with an identification of all the creatures. To Tom Fink, for graciously allowing me to tinker around his lab and teaching me how to use the Scanning Electron Microscope. To Rob Dunn, for recognizing the intangible gridwork connecting science and the arts. To Dennis Sipiorski, my first art professor and mentor, for always being himself and teaching me the value of hard work. To my parents, Melita and Josip, for their unyielding support and courage to let go. And finally, above all, to my wife, Annette, whose love, humor, appreciation of art experiments, and tolerance of all weird things in our freezer is unsurpassed.